Raymond S.

(1913 - 1958)

Master Illustrator

CATALOGUE NOTES

Relatively little primary source information exists about Raymond Sheppard. This catalogue has drawn heavily on three of Raymond Sheppard's educational texts:

How to Draw Birds, Published by The Studio Publications, London & New York, 1940

Drawing at The Zoo, Published by The Studio Publications, London & New York, 1949

More Birds to Draw, Published by The Studio Publications, London & New York, 1956

These are referred to in the catalogue text as *RS1*, *RS2* and *RS3*, followed by the relevant page number.

Raymond Sheppard: Capturing the Moment, Published by Langford Press / The Wildlife Art Gallery, 2009 is referred to in the catalogue text as *Langford*, followed by the relevant page number.

FOREWORD

Had Raymond Sheppard lived beyond his mid 40s his reputation as one of the foremost illustrators of his generation might have been secured – his premature death resulted in his name sinking into obscurity for half a century.

Only his prolific career as an illustrator (nearly 100 children's books in the single decade following the end of WW2) has prevented his name from disappearing altogether and secured him a credible place in the standard reference works of the period. What has never been appreciated before is the remarkable diversity of Raymond Sheppard's oeuvre. Aside from his more familiar studies of wildlife his studio has revealed a series of remarkable portraits, thrilling *boy's-own* period illustrations, *plein air* seascapes, landscapes, views of the Thames and surreal compositions, which at times verge on abstraction. All have in common Sheppard's stated aim to express his inner emotion:

"...that peculiar, unexplainable tightening inside that makes you want to laugh sometimes, sometimes to sing and dance for joy, and sometimes just a little sad" (RS1, pages 15-16).

Paul Liss and Sacha Llewellyn
October 2010

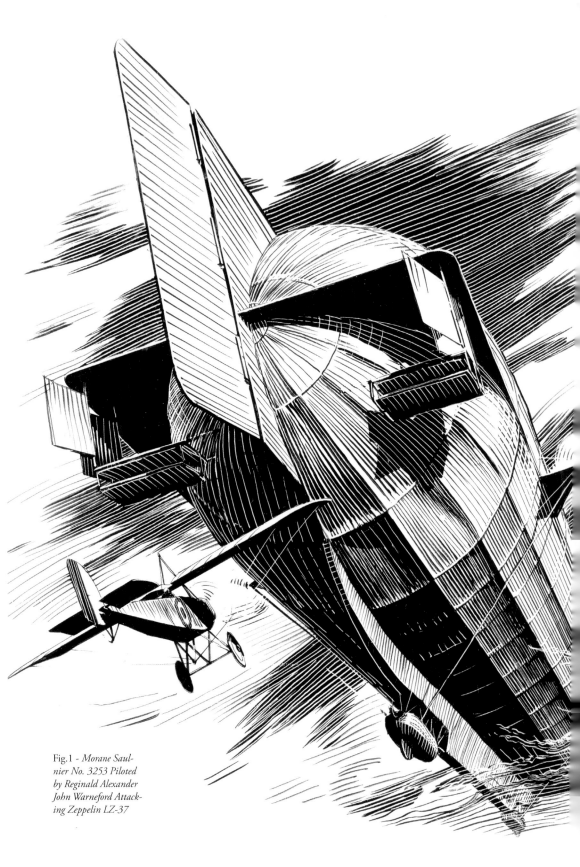

Fig.1 - *Morane Saul-
nier No. 3253 Piloted
by Reginald Alexander
John Warneford Attack-
ing Zeppelin LZ-37*

CONTENTS

ACKNOWLEDGEMENTS

This catalogue would not have been possible without the unstinting help and support of Christine Sheppard, the artist's daughter. All quotes and information have been supplied by Christine unless otherwise stated.

We would also like to acknowledge the following:

Graham Barker
Norman Boyd
Ken Breinburg
Barbara Carr
Simon Edsor
Andrew Haslen
Alistair Hicks
Ian Langford
Conor Mullan
Martin and Rosemary Pearson
Vivien Sheppard
Michael Sheppard
Tom Sheppard
Peyton Skipwith
Simon Trapnell
Luc Venet
John Yates

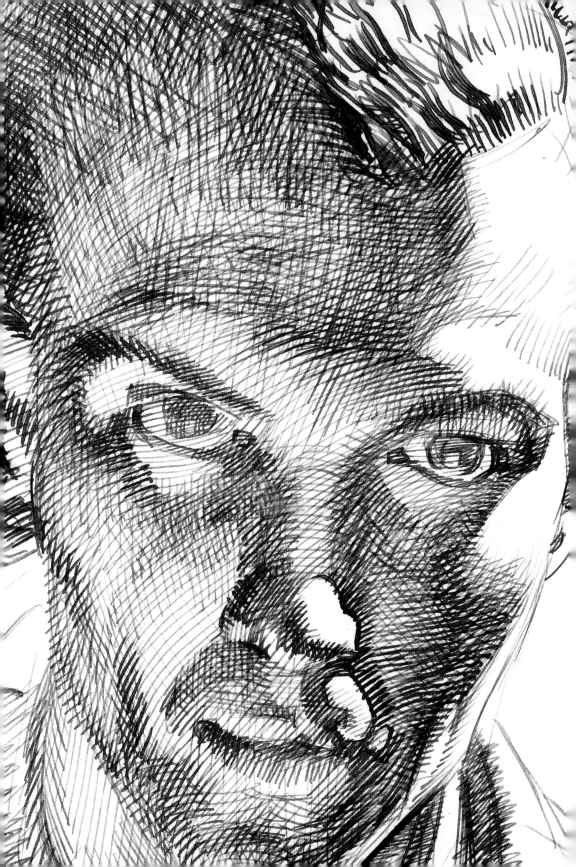

INTRODUCTION

"…..it is under the great arch of heaven in the pure and sparkling air, you in your imagination can fly into unknown and pleasant regions of the mind, to that perfection of Beauty towards which all art aspires."

Raymond Sheppard,
How to Draw Birds, 1940
(page 16)

Cat. 15 - *Self Portrait,*
1941 (Detail)

Raymond Sheppard was born on March 3rd 1913 in Muswell Hill, and educated at Christ's College Finchley in north west London. His father, Edward, was Irish and his mother, Annie, English; of mixed middle and working class background both raised in Lancashire. Edward worked as a manager for Pilkington's Pottery, sourcing designs. Annie, (nee Yates), who had attended The Municipal School of Art in Manchester, also worked for Pilkington's and was an accomplished painter (mostly of still lives and flowers) as well as a skilled needle-woman.

Raymond Sheppard showed an early interest in both art and nature and aged 15 enrolled in the Elementary Course of John Hassall's Correspondence Art School where he was complimented on *"his remarkable understanding of the correctness of drawing"* (*Langford, page 15*). From 1931 he studied at the London County Council School of Photo-Engraving and Lithography, (Bolt Court Fleet Street), under S.G. Boxsius - a non fee paying technical college where students were able to take classes in design, drawing, lettering, engraving and photo-mechanical processes.

In 1934, at the age of 21, he embarked on a career as a freelance artist, taking commissions for advertising and illustration. He received a modest number of commissions to illustrate children's stories working for the publishers Routledge, Blackie and Son and Nelson, but in the pre-war era he struggled financially. When not undertaking commissions he passed hours studying at the London Zoo, Regents Park – the only way for an artist of limited means to see live animals, birds and insects from around the world. Through this training he began to excel in the genre of drawing wildlife, noting modestly some years later *"… whilst I have still to overcome the major difficulties of my own limitations, I have, by experience overcome some of the practical problems involved in drawing from live animals"* (RS2, page 9).

Sheppard's talent for drawing wildlife gained recognition with the success of the first of his three books for The Studio Publications *How to Draw* Series. *How to Draw Birds,* published in 1940, not only ran to four reprints during WW2 but a further two reprints afterwards in 1948 and 1955 – a remarkable feat for a 27 year old artist. This not only provided Sheppard with a secure, if modest, financial income but put him on a stage alongside the highly regarded draughtsman of this genre John Skeaping (*How to Draw Horses*) and C.F. Tunnicliffe (*How to Draw Farm Animals*) both of whom were 12 years his senior.

In parallel to his work as an illustrator of wildlife, Sheppard, along with Jack Merriott as President, became a founding member of the Wapping Group. Limited to 25 members, *The Wappers*, as they were known, comprised artists from the Langham Sketching Club, (which did not meet in the summer months,) who convened along the river between Westminster and Gravesend, in the East End of London, to paint scenes along the Thames.

Sheppard emerged after the war with a bankable reputation, and, helped by a revolution in printing methods which allowed for the mass production of illustrated books, picked up a growing number of prestigious commissions. These included two books by Enid Blyton (c. 1948), six for Jim Corbett (1952-57) and, perhaps most notable of all, a commission to illustrate the first edition of Ernest Hemingway's *The Old Man and the Sea* (1952).

A commission from Esso in the early 1950s to design a (now familiar) Tiger logo (Fig. 2) bought with it further financial security and allowed Sheppard to move from Kenton to a larger family home in Harrow Weald. The productivity of his post war period is all the more remarkable because in the background he was fighting a battle against cancer (the illness had been diagnosed in the mid 1940s). Sheppard died on April 21st 1958, aged 45.

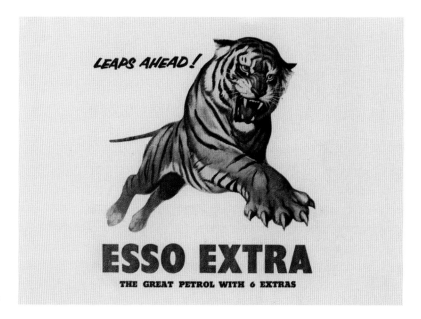

Fig. 2 - ESSO Tiger, *Punch Magazine,* June 10, 1953

Although little was published about Raymond Sheppard during his lifetime, the three books he wrote for the Studio *How to Draw* series offer help in understanding more about his motivation as an artist. Ultimately all subjects for Sheppard worked on an abstract level – his books refer continuously to the importance of *"deciding what to put in and what to leave out"* and seeing properly and quickly *"the important shapes and main lines or rhythms of a pose"* (*RS1, page 12*).

"…what is really the most important thing in any drawing? It is what artists call 'Feeling.' … that quality in your drawing which shows that you have yourself had an exciting experience, that you felt wonder at the flowing rhythm … almost unconsciously this will show in your drawing and make it a work of art, a thing of beauty" (*RS1, pages 15-16*).

Sheppard made frequent references to the artists who most inspired him. He described R.B. Talbot Kelly's *The Way of Birds* as *"stimulating and exciting"* and Tunnicliffe's *Bird Portraiture* as containing *"many lovely drawings"* (RS2, page 53). *Animal Drawing* by John Skeaping he referred to as *"a most stimulating and scholarly book by a great contemporary animal draughtsman".* Warwick Reynolds, Sheppard noted, *"obtained wonderful effects of texture and pattern with conte on quite cheap cartridge paper"* (RS2, page 10). His greatest admiration, however, was reserved for Joseph Crawhall, who managed *"...to depict not only the main essentials of form, but those intimate details of structure which place his bird and animal pictures amongst the finest in the world, so very alive and vital are they"* (RS2, page 14).

Sheppard collected works by other artists, as much as his modest means would allow, especially Frank Brangwyn, Fortunio Matania, Gustave Doré and Japanese prints which he found a particular source of inspiration: *"Japanese artists who produced such lively colour prints during the eighteenth and nineteenth centuries were masters at drawing groups of flying birds"* (RS3, page 47). Sheppard admired both the compositional devices of Oriental art and the implied approach to the animal world: *"The finest painters of animals and bird life are perhaps those of the great Chinese and Japanese artists who regarded animals, bird and insects with a sincere humility as fellow creatures inhabiting the world and worthy subjects for the brush.... An outlook at once poetic and intimate, whose technique was developed from a habit of contemplation - he observed, and remembered, then swiftly his brush gave expression to the image"* (RS2, page 7).

If Raymond Sheppard's drawings are to been seen as something more than illustrations the key is here: *"An outlook at once poetic and intimate, whose technique was developed from a habit of contemplation".*

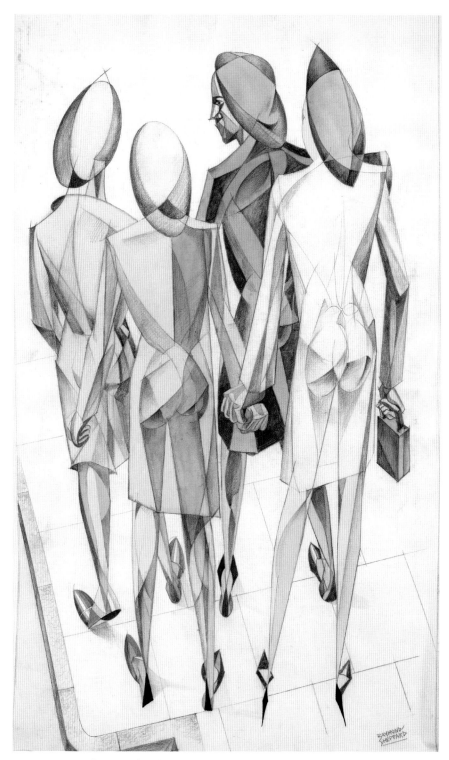

Cat. 1 - *Women Walking*, signed, 1940s, pencil and watercolour on paper, 20 7/8 x 12 1/4 in. (53 x 31 cm.)

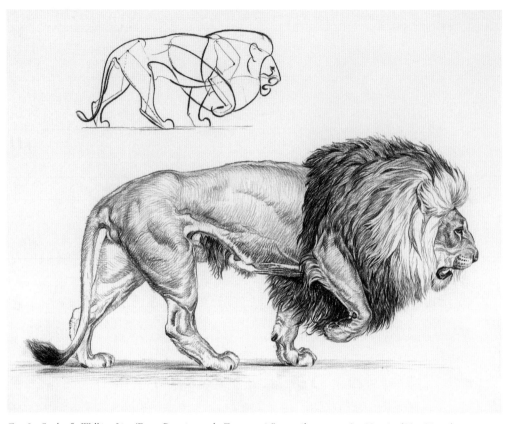

Cat. 2 - *Study of a Walking Lion* (From *Drawing at the Zoo,* page 36), pencil on paper, 9 x 12 1/4 in. (23 x 31 cm.)

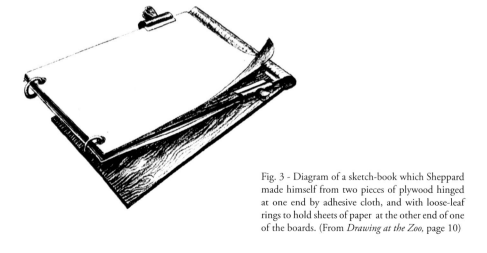

Fig. 3 - Diagram of a sketch-book which Sheppard made himself from two pieces of plywood hinged at one end by adhesive cloth, and with loose-leaf rings to hold sheets of paper at the other end of one of the boards. (From *Drawing at the Zoo,* page 10)

TECHNIQUE

Sheppard's three books for the Studio *How To Draw* series provide invaluable information about the materials he used and his approach to making pictures.

"My favourite mediums are black conte chalk on toned paper, with white chalk for the lights, or black conte or carbon pencil on cartridge. ….A fairly soft pencil is almost as good" (RS2, page 10). *"For rapid sketching it doesn't matter what you draw with – whether it be pen, pencil or chalk…."* For his own work he mostly favoured a carbon pencil on cartridge paper but stressed the importance of experimenting with different mediums such as *"carbon pencil or conte, pen and wash or wash alone.… The artists of ancient China and Japan always drew directly with a brush and its sensitive fluent tip is really the finest drawing instrument in the world"* (RS3, page 24).

Sheppard usually carried a mixture of plain, toned, rough or smooth paper with him. He recommended *"ordinary brown wrapping paper* (which) *gives a nice middle tone* (and) *a black conte crayon with white for the lights. This is a very useful way of making complete tone studies"* (RS3, page 52).

"I draw that particular aspect of a (subject) which appeals to me; sometimes shape, sometimes pattern and texture and sometimes a briefly held attitude…." (RS3, page 10) *"….the whole secret of drawing is to learn to 'see properly'…. To see those big simple shapes upon the surface of which these accessories are placed"* (RS1, page 9).

To start a drawing Sheppard recommended that students *"take a large sheet of paper pinned to a board and make lots of drawings. Each time the bird moves start a fresh drawing… Try looking hard*

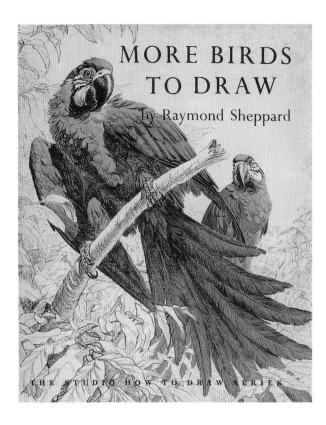

Fig. 4 - Cover of Raymond Sheppard's book *More Birds to Draw*, The Studio Publications, London and New York, 1956

and notice what are the main lines of a pose and put them down in free, long strokes. It will surprise you how a few lines can suggest a lot..." (RS1, pages 13-14).

After sketching at the zoo Raymond Sheppard cut out his favourite studies and arranged them in a pattern book for future use. *"Sometimes one gets the idea for a picture a long time after the study has been made. I keep my studies in easily identified folders so that if the need arises I can look through all the studies, made over a period of time, of one particular species and sort out those necessary to help in composing a picture"* (RS3, page 63).

Sheppard frequently made drawings from nature to be used as backgrounds for bird pictures. He would often draw in the Palm House at Kew Gardens or make studies in the Natural History museum : *"It is extremely useful too, to make very careful drawings in a museum of Natural History. … One is able to concentrate* (as when working on) *a piece of still life"* (RS3, page 34).

Cat. 3 - *Studies, The Natural History Museum*, late 1930s, watercolour on paper, 11 3/4 x 9 in. (30 x 23 cm.)

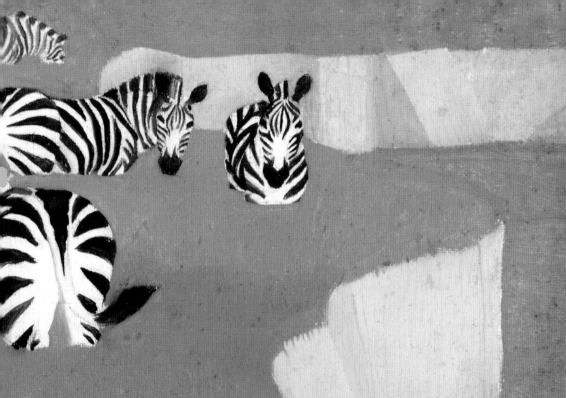

Early Work

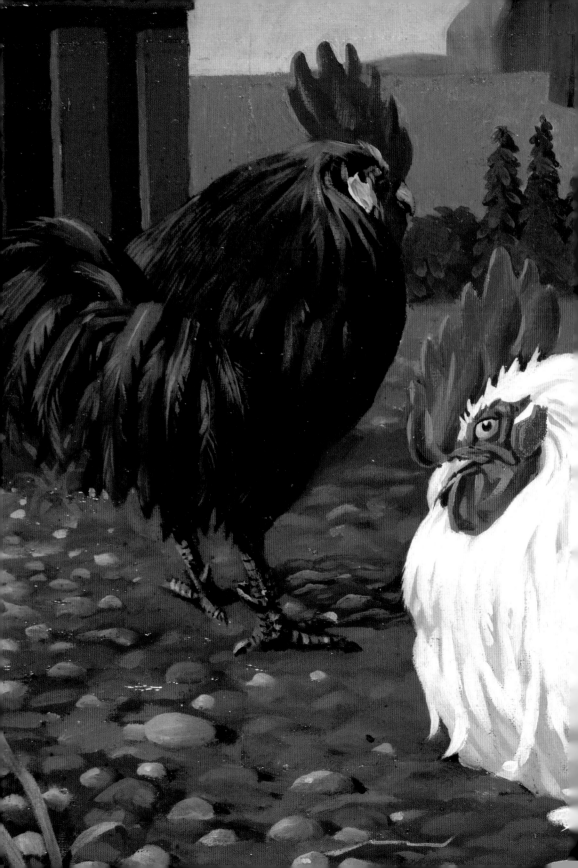

EARLY WORK

Sheppard started his professional career at the age of 21 in 1934. The first undercurrents of Surrealism were beginning to agitate British Art of the period and early compositions such as *Lion Stalking Zebras* (Cat. 13) suggest that Sheppard already had a natural empathy with the Surreal aesthetic.

Sheppard completed a number of paintings in oil during his student years, a medium he was to favour less as he evolved as an artist. In the pre-war era, although he received a modest number of commissions to illustrate children's stories and annuals, and started to contribute regularly to magazines such as *Boy's Own Paper* (see pages 125-126), he struggled financially. The cost of materials might have steered him away from oil painting and certainly the ability to work rapidly and on the spot, in pencil on paper, was something Sheppard naturally favoured.

Cat. 12 - *The White Cockerel, No. 1,* c. 1935, (Detail)

"Although not a British Bird in the strict sense of the word, the domestic fowl is such a typical part of the farm and countryside. Points to notice are the wedge-like shapes of the masses, particularly the hen – which is not a very beautiful bird, unless one searches very carefully for the main lines and rhythm which follow through her rather ungainly bulk. The Cockerel, however, is a very lordly bird, and in the hands of the artist is full of great decorative possibilities, particularly in the curve of the sickle feathers which hang over the real tail" (RS1, page 52).

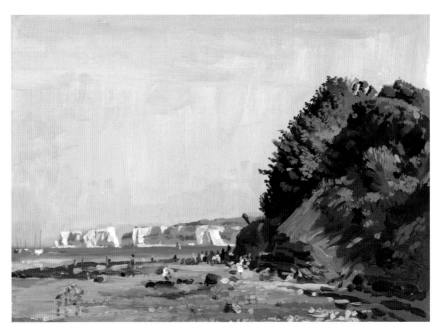

Cat. 4 - *Studland Bay, Dorset,* signed, oil on "Rathborn" canvas board, 12 x 16 in. (30.5 x 40.5 cm)

Cat. 5 - *St David's Wales,* c. 1940, signed, oil on board, 12 x 16 in. (30.5 x 40.5 cm)

Cat. 6 - *Self Portrait,* c. 1930, oil on "Dalston" canvas board, 16 x 12 in. (40.6 x 30.5 cm.)

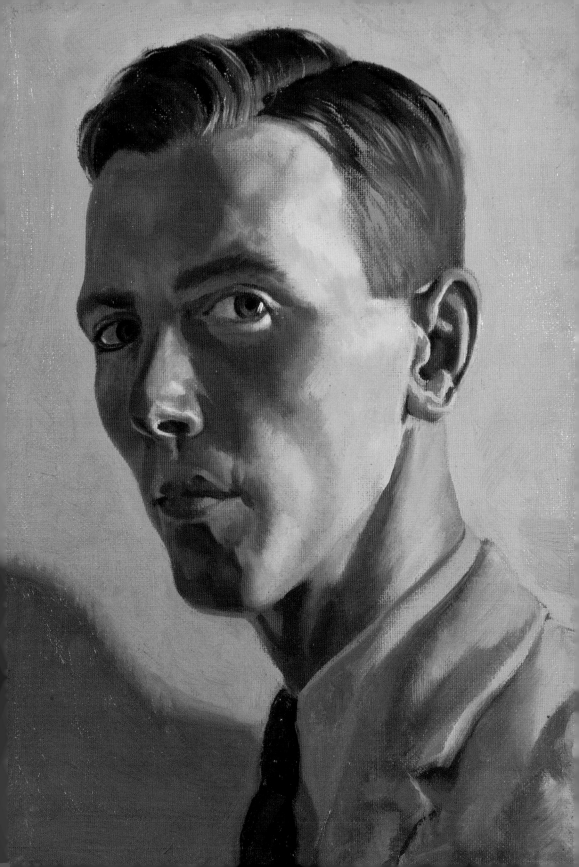

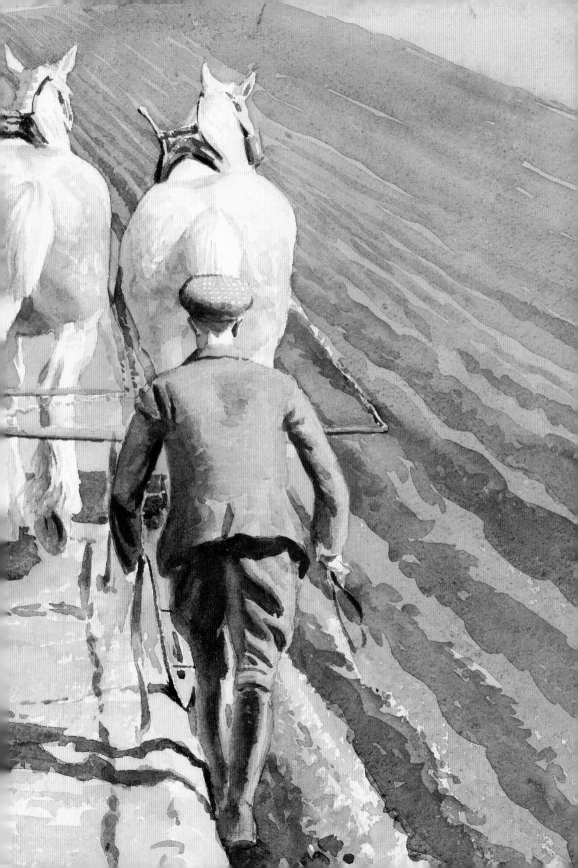

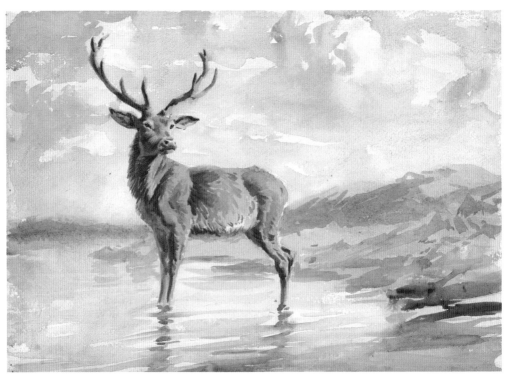

Cat. 7 - *Monarch of the Glen,* late 1930s, watercolour on paper, 11 x 15 1/4 in. (28 x 39 cm.)

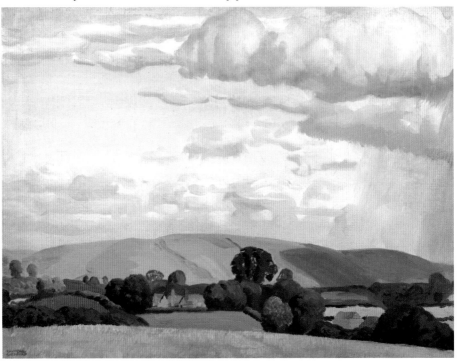

Cat. 8 - *The Quantock Hills,* late 1930s, signed, oil on "Rathborn" canvas board, 12 x 16 in. (30.5 x 40.5 cm)

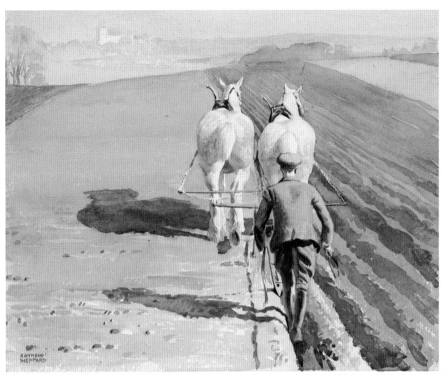

Cat. 9 - *Ploughing*, late 1930s, signed, watercolour on paper, 14 x 17 3/4 in. (35.5 x 44.5 cm.) Pages 24-25: detail

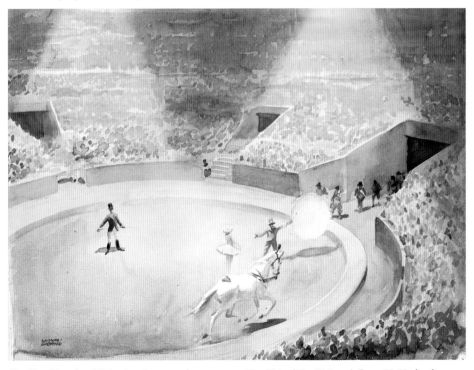

Cat. 10 - *Circus*, late 1930s, signed, water-colour on paper, 15 x 20 in. (38 x 50.8 cm.) Pages 28-29: detail

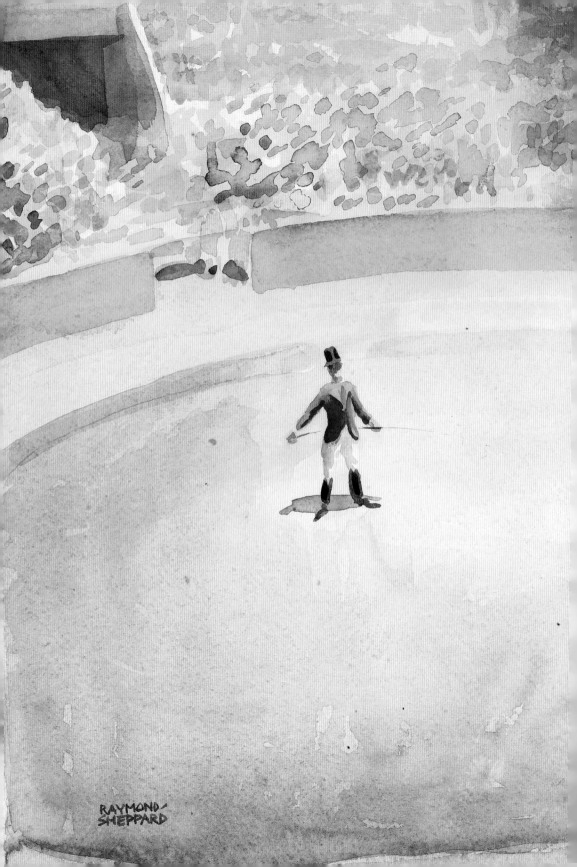

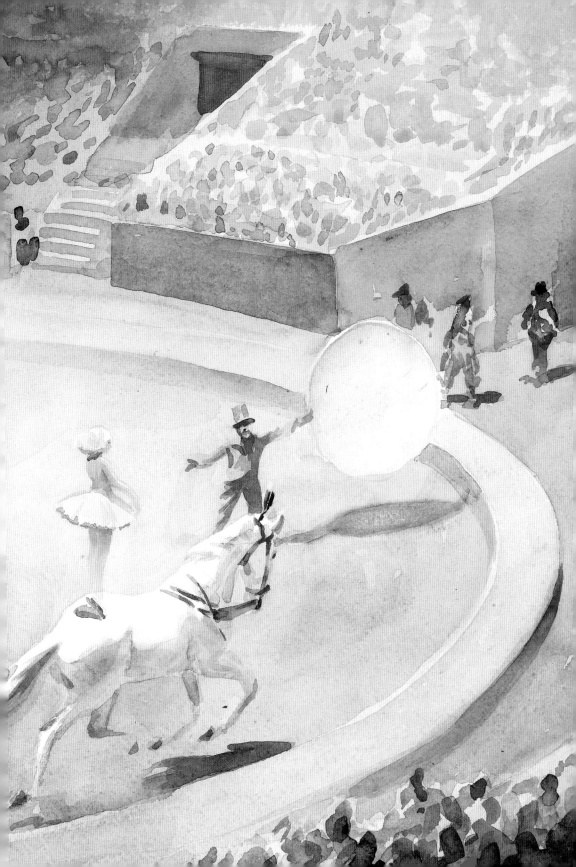

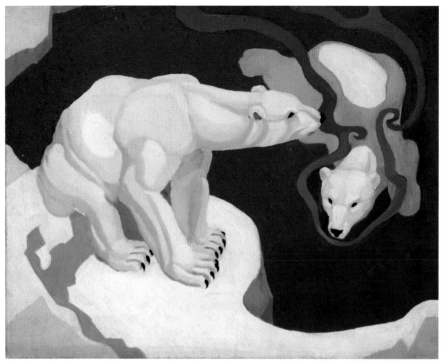

Cat. 11 - *Polar Bears,* c. 1934, signed, and inscribed on label to reverse, oil on Winsor & Newton's "Rathbone" canvas board, 16 x 20 ins. (40.6 x 50.8 cm.)

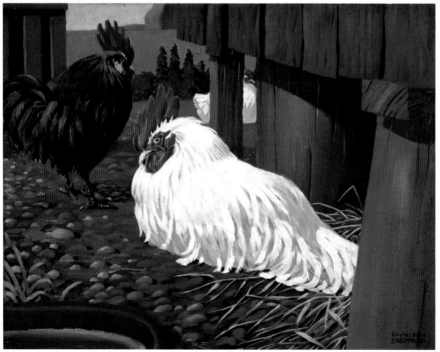

Cat. 12 - *The White Cockerel, No. 1,* c. 1935, signed, oil on Winsor & Newton's Rathbone canvas board, 16 x 20 in. (40.6 x 50.8 cm.)

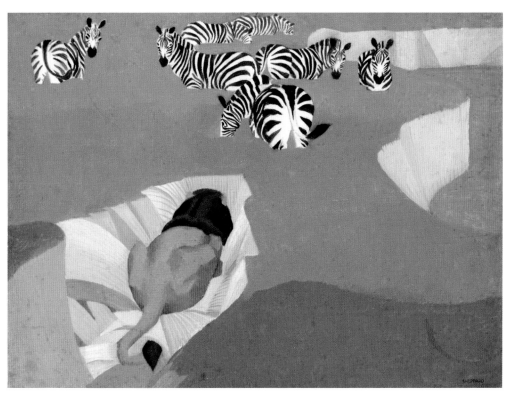

Cat. 13 - *Lion Stalking Zebras,* 1934, signed, dated on reverse, oil on "Rathborn" canvas board, 12 x 16 in. (30.5 x 40.5 cm)

The Surreal flavour of this painting is heightened by the ambiguous setting which can be read either as long grass by a blue pool on the African plains or, equally, a grass covered clifftop view along the English coast.

*The Artist
and His Family*

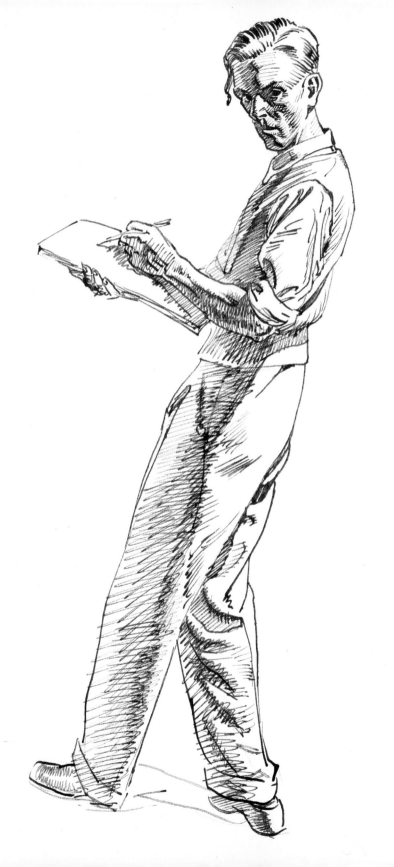

THE ARTIST AND HIS FAMILY

Until 1954 Raymond Sheppard and his family lived in a small three-bedroom house in Kenton, North West London where the downstairs front room served as his studio, (and often the children's playroom). It was here that he spent many hours sketching, drawing and painting his wife Iris and his children, (Christine, born 1944, Michael born 1946). Christine was undoubtedly the most frequently drawn family member – and both Michael and she were regularly asked to pose for a particular illustration: *"Often our father would sit and sketch us as we were playing. When the pressure was on to complete an illustration for a deadline, we would be asked to hold a pose in a particular position so he could capture the exact line of an elbow, turn of the head etc. …. I remember posing many many times for my father. Sometimes we were paid pocket money for sittings, especially when we didn't feel like sitting still! I think we wanted to help our dad and were mainly willing."* (Christine Sheppard, email to Paul Liss 3 May 2007)

Sheppard clearly spent hours observing his children at play in their domestic environment and this resulted in a remarkable series of watercolours which are reminiscent of the celebrated interiors with children of the Swedish illustrator Carl Larsson.

Cat. 14 - *Self Portrait Sketching*, mid 1940s, pen and ink on paper, 13 ¾ x 8 ¼ in. (35 x 21 cm.)

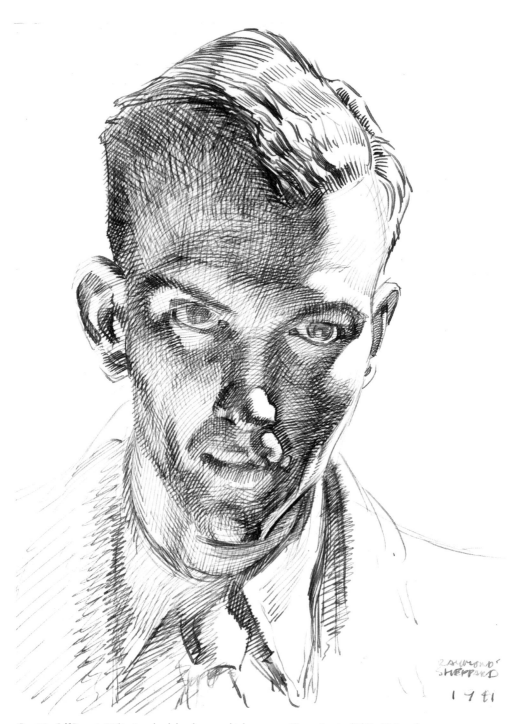

Cat. 15 - *Self Portrait*, 1941, signedand dated, pen and ink on paper, 10 1/2 x 8 3/4 in. (26.7 x 22.5 cm.)

Cat. 16 - *Self Portrait Sketching*, c. 1935, pen and ink, 10 3/4 x 5 3/4 in. (27.5 x 14.5 cm.)

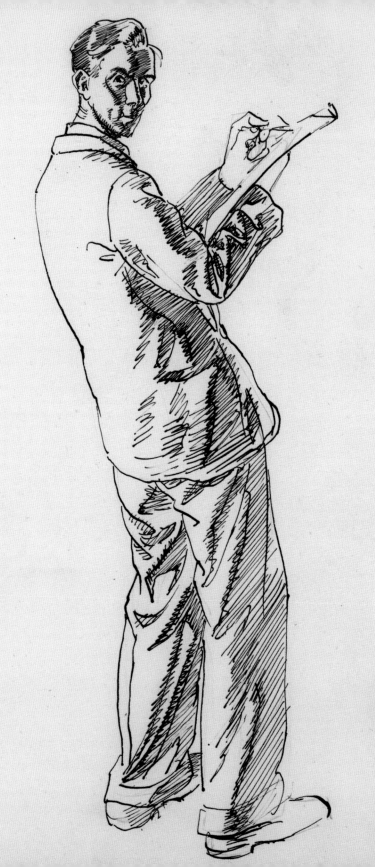

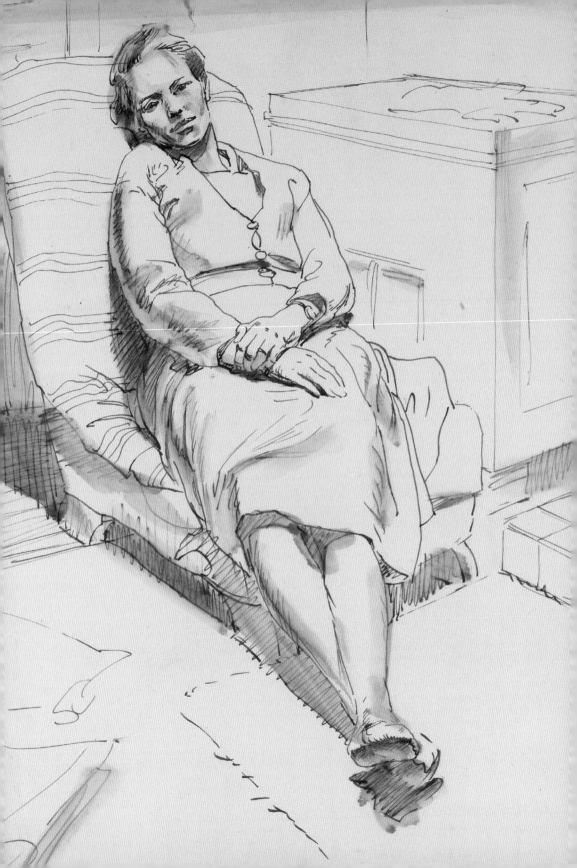

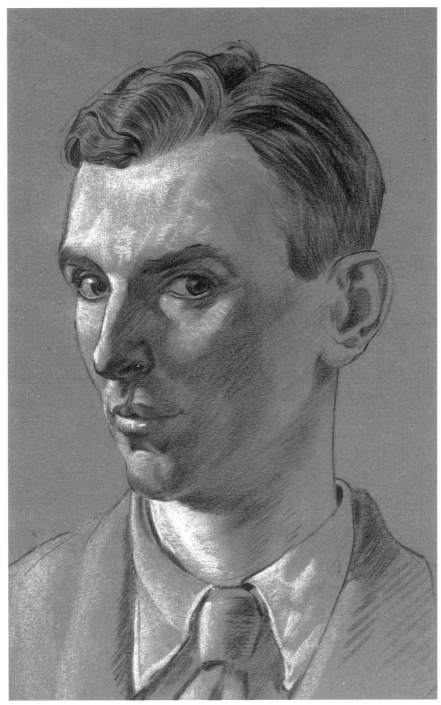

Cat. 18 - *Self Portrait Glancing to the Left, c.* 1940, black chalk with white highlights on dark grey textured paper, 12 3/4 x 8 1/2 in. (32.5 x 21.8 cm.)

Cat. 17 - *The Artist's Wife Iris Listening to the Wireless,* pen and ink with wash on paper, 13 1/2 x 9 1/2 in. (34.3 x 24 cm.)

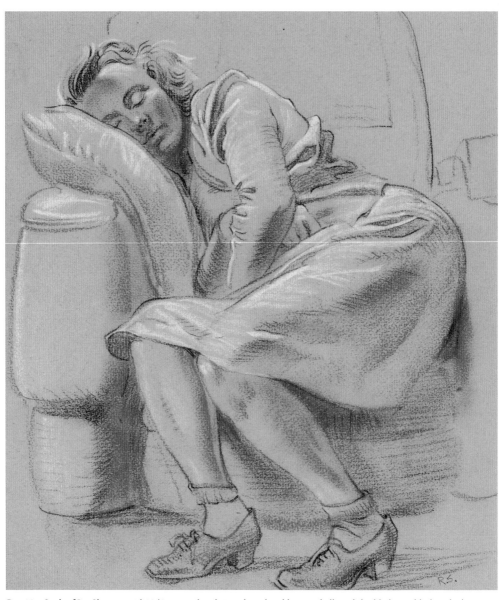

Cat. 19 - *Study of Iris Sleeping*, mid 1940s, signed with initials, red and brown chalk with highlights in black and white chalk on grey paper, 12 x 10 in. (30.5 x 25.5 cm.)

Cat. 20 - *Michael with Toy Car*, c. 1952, pen and ink and watercolour on paper, 15 x 11 in. (38 x 28 cm.)

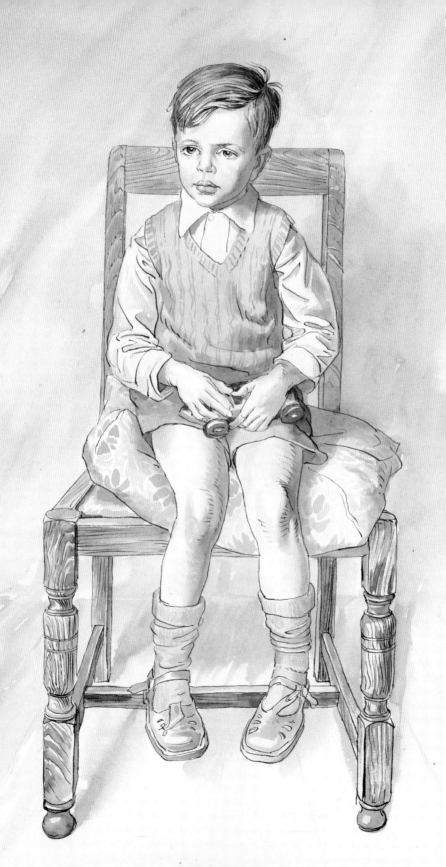

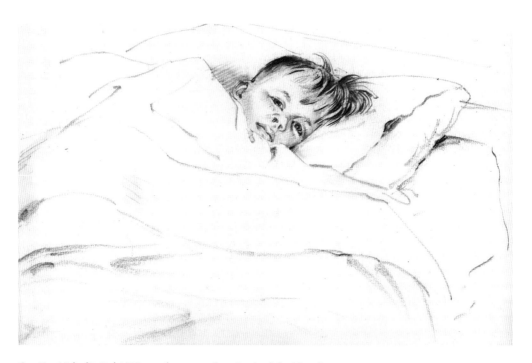

Cat. 21 - *Michael in Bed,* 1953, pencil on paper, 6 1/4 x 9 3/4 in. (16 x 25 cm.)

Cat. 22 - *Portrait of Michael,* c. 1950, red pencil on paper, 7 1/2 x 6 1/8 in. (19 x 15.5 cm.)

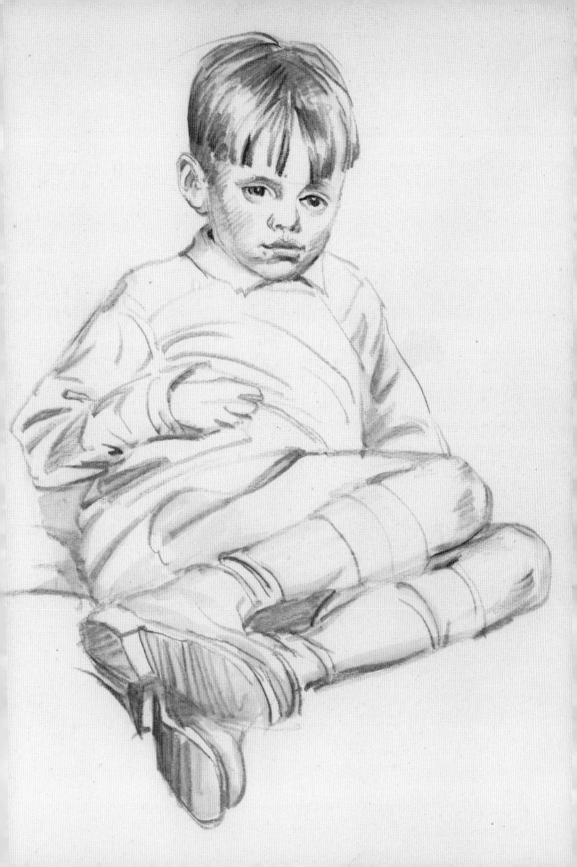

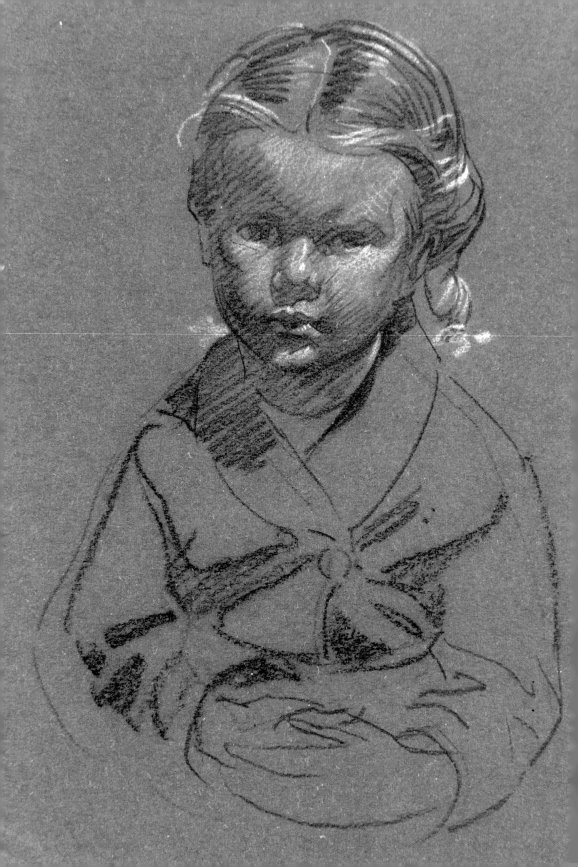

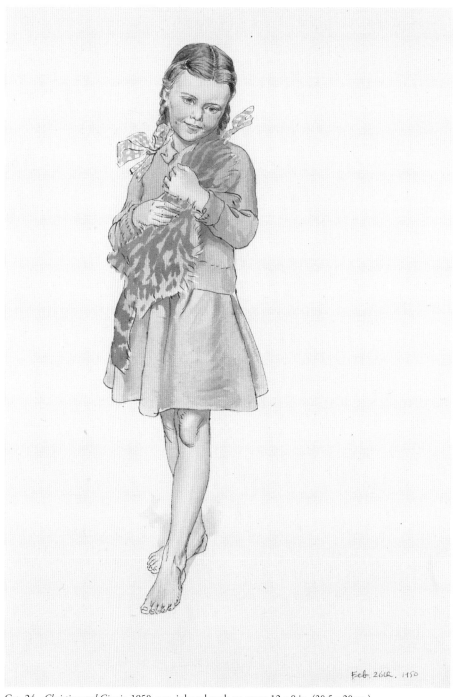

Cat. 24 - *Christine and Ginnie*, 1950, pen, ink and wash on paper 12 x 8 in. (30.5 x 20cm.)

Cat. 23 - *Portrait of Christine,* c. 1950, black chalk with white chalk highlights on grey paper, 6 3/8 x 5 in. (16.2 x 12.5 cm)

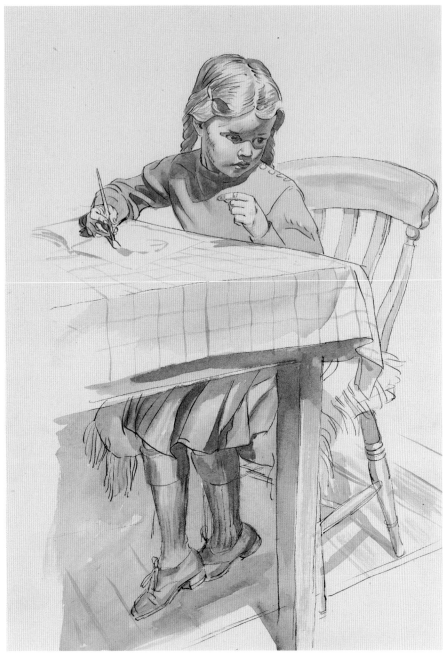

Cat. 25 - *Christine Sketching at the Kitchen Table, 65 Dorchester Way,* c.1952, watercolour and pen and ink on paper, 14 x 10 in. (36 x 25.5 cm.)

Right: Cat. 26 - *Christine Seated on a Stool with Doll Called Sylvie,* c. 1950, watercolour and pen and ink on paper, 12 x 9 in. (29 x 22.8 cm.)

Pages 48-49: Cat. 27 - *Christine and Teddy Bear,* waterclour on paper, 9 7/8 x 13 3/4 in. (25 x 35 cm.)

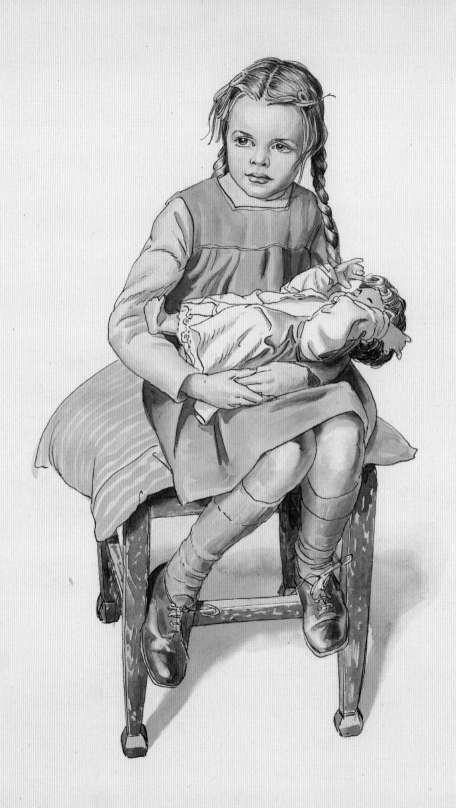

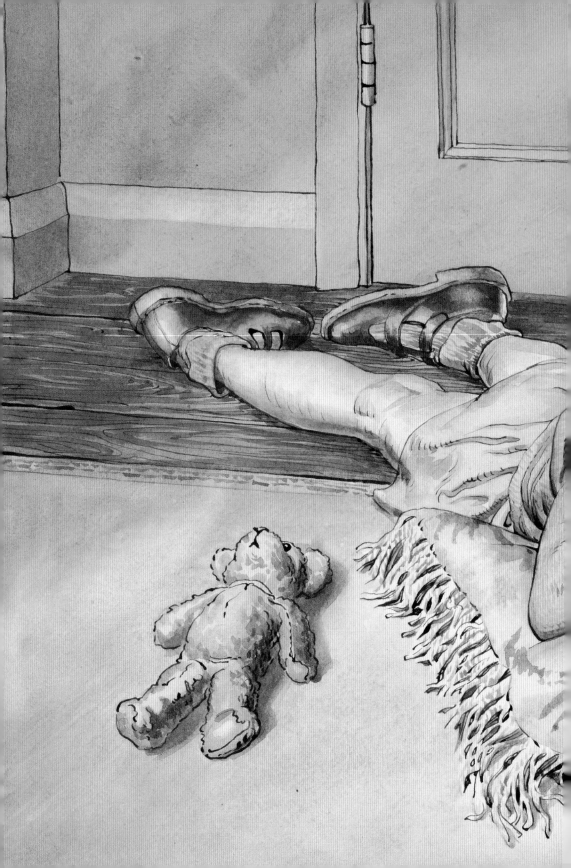

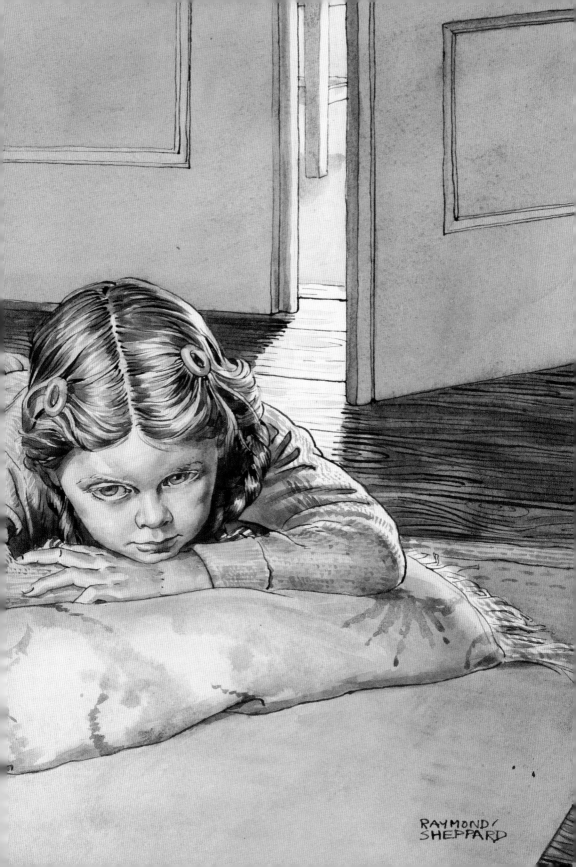

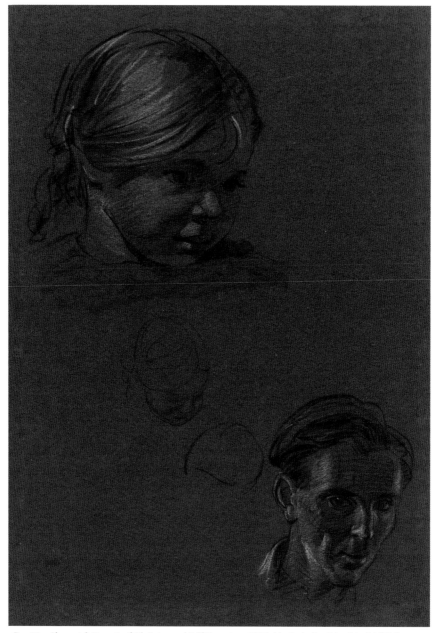

Cat. 28 - *Sheet with Portrait of Christine and Self Portrait,* c. 1950, black chalk with white highlights on brown paper, 9 7/8 x 6 15/16 in. (25 x 17.6 cm.)

Right: Cat. 29 - *Christine Seated on a Stool,* c. 1950, watercolour and pen and ink on paper, 14 x 10 in. (36 x 25.5 cm.)

Pages 52-53: Cat. 30 - *Michael and Christine With Toys and Books,* signed, watercolour over pen and ink on Whatman board, 11 x 15 in. (28 x 38 cm.)

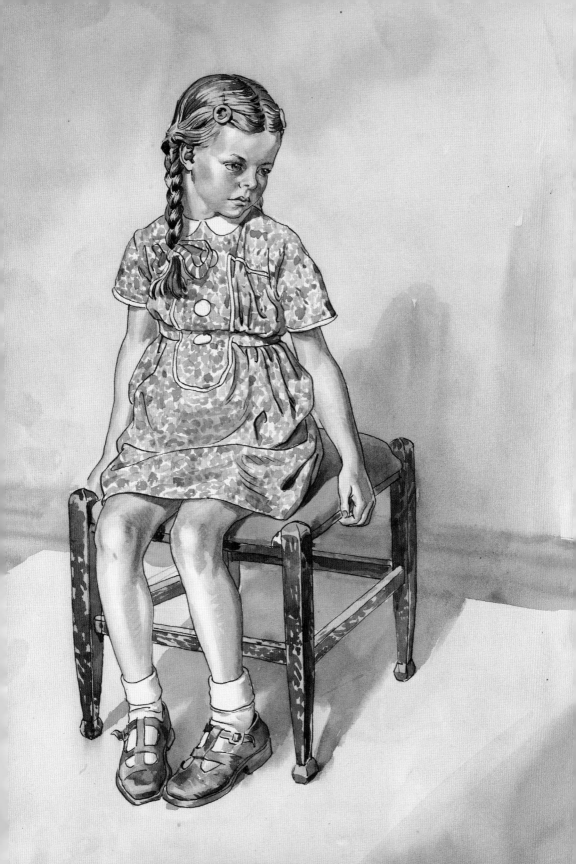

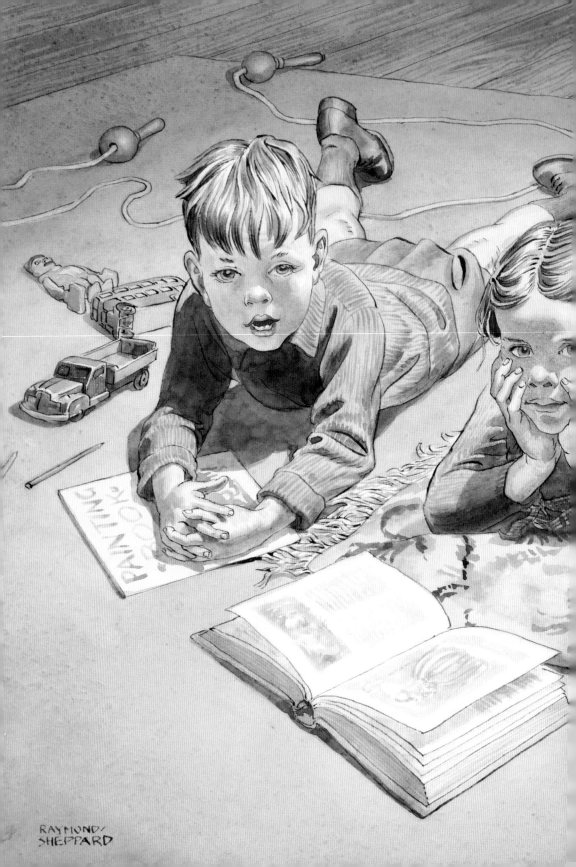

RAYMOND/
SHEPPARD

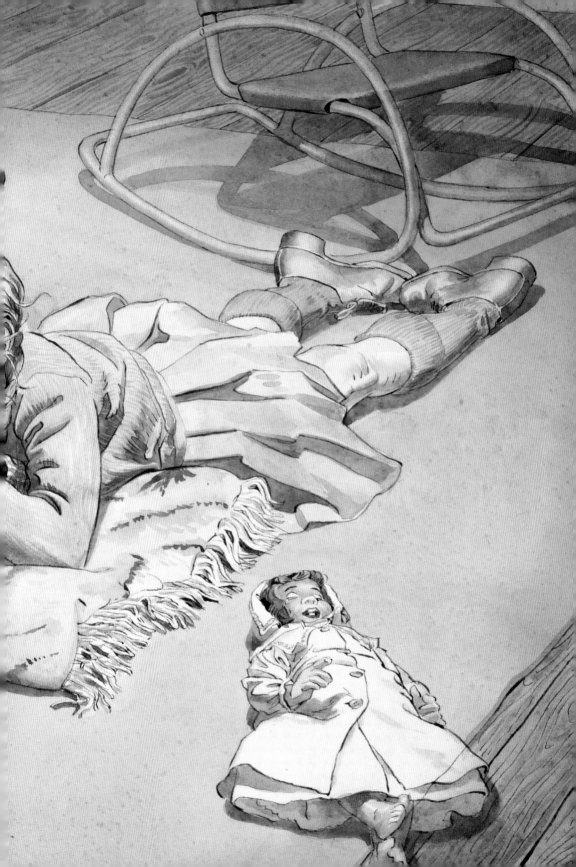

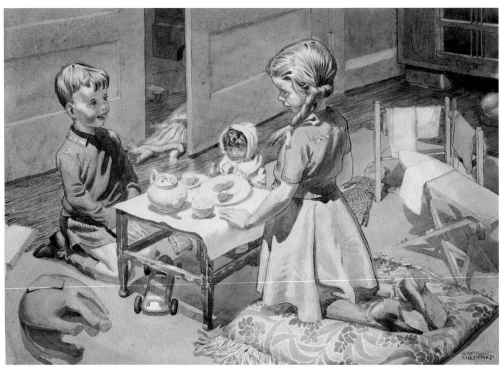

Cat. 31 - *Michael and Christine, a Tea Party* 1950, watercolour on paper, 10 x 14 1/2 in. (25.3 x 36.7 cm.)
Exhibited at the Royal Academy, 1950 (722) Right: detail

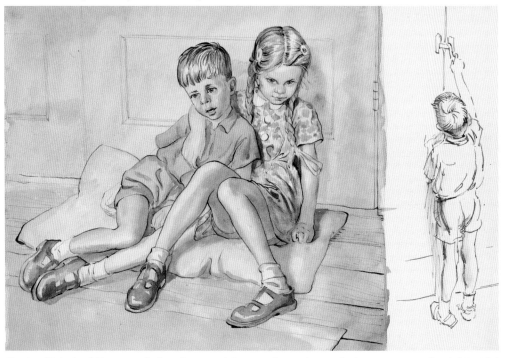

Cat. 32 - *Michael and Christine in the Front Room,* c. 1950, watercolour and pen and ink on paper, 10 x 14 in. (25.5 x 35.5 cm.)

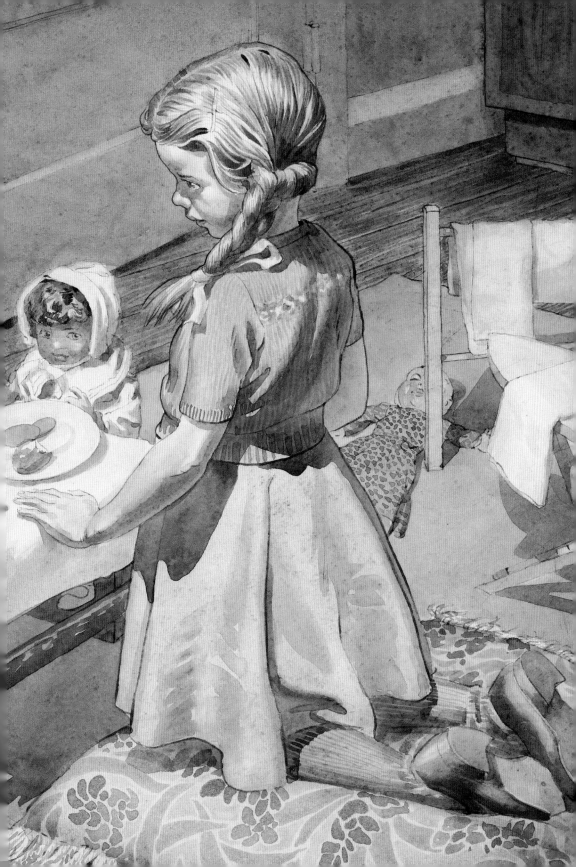

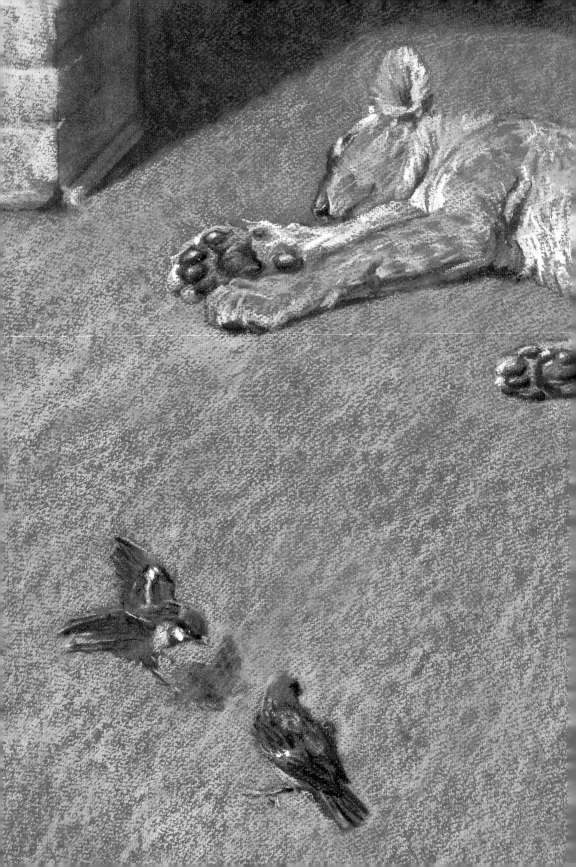

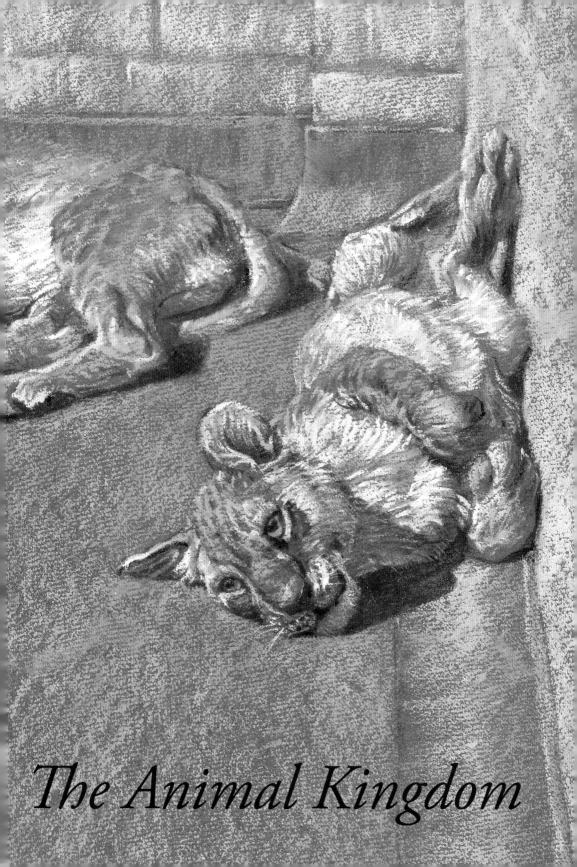

The Animal Kingdom

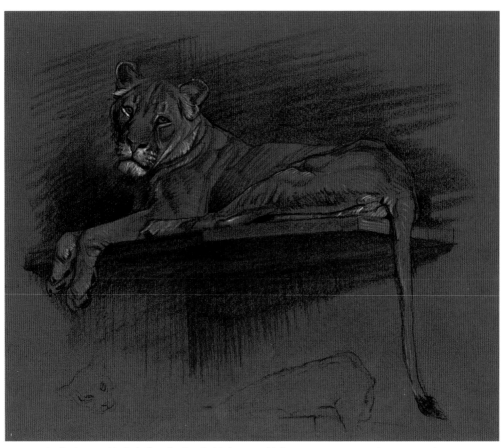

Cat. 33 - *Study of Lioness*, black chalk with white highlights on reddish paper, 8 1/2 x 9 3/4 in. (25 x 21.5 cm.)

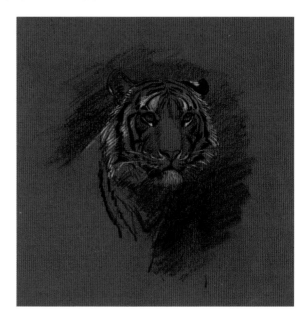

Cat. 34 - *Study of Tiger*, black chalk with white highlights on reddish paper, 5 1/4 x 5 1/4 in. (13.5 x 13.5 cm.)

THE ANIMAL KINGDOM

Drawing animals encompassed a larger universe for Raymond Sheppard than a simple area of genre painting. He saw it as a part of a much bigger tradition in art linking his own interests with the earliest traditions of artistic expression: *"This purely visual interest in animals goes right back to pre-historic times; to the days when the cavemen, realizing an animal's graphic possibilities, first scratched on bone their crude records of the chase"* (RS2, page 6).

Sheppard admired *"Durer, Rembrandt, Pisanello and Leonardo da Vinci"*, but lamented the fact that *"European artists have regarded the animal as subject matter of secondary importance."* His own approach was similar to that of Oriental artists where observation was akin to an an act of contemplation. *"When you draw an eagle, try, in imagination, to be an eagle. If you can do this, almost unconsciously this will show in your drawing and make it a work of art, a thing of beauty"* (RS1, page 16).

Sheppard saw his animal studies as ultimately transcending their subject matter. *"The whole secret is to learn to 'see properly'...to see those big simple shapes. It is so exciting to get just the right lines, to suggest an attitude or rhythm momentarily observed"*(RS1, page 8).

Pages 60-61: Cat. 35 - *Two Leopards Courting,* pastel on brown paper, 8 1/4 x 12 1/2 in. (21 x 32 cm.)

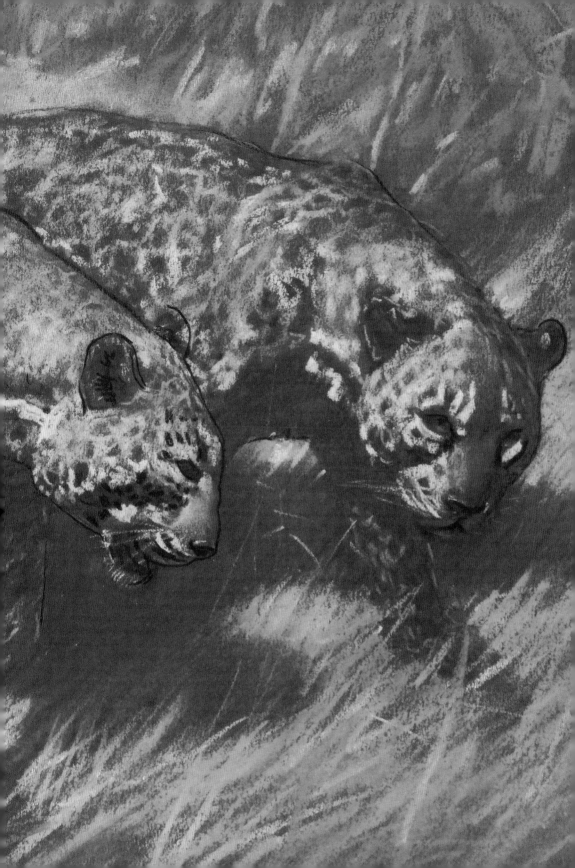

WILDLIFE

As a student artist in the 1930s Sheppard studied at the London Zoo, Regent's Park, and after1954 - when he was able to buy his first car (a Hillman Minx) - at Whipsnade Zoo, Dunstable. *"My father's enthusiasm for and professional dependence on the Zoo was completely understandable. The Zoo was the source of the world of wildlife for an artist on a low income."* (Christine Sheppard, quoted *Langford, page 173*)

Right:
Cat. 37 - *Leopard and Head of a Lion,* c. 1940, pencil with coloured crayon highlights on paper, 13 3/4 x 9 3/4 in. (35 x 25 cm.)

Sheppard's favourite wildlife subject was the tiger: *"Of all the large cats, the tiger is my favourite. What a splendid model he makes either asleep or resting…"* (*RS2, page 32*). He excelled in drawing polar bears and the *"graceful impala"* with all its *"qualities of rhythm and fluency of line…. A nervous, highly strung creature* (that will) *make your line equally nervous and sensitive…"* (*RS2, page 47*). Sheppard was also drawn to unusual animals such as the hippopotamus. *"Although such an ungainly beast I enjoyed drawing his full rich forms. …All the real interest is in the head and the feet"* (*RS2, page 26*).

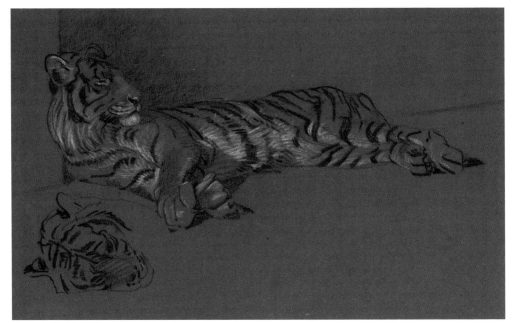

Cat. 36 - *Study of a Tiger,* black chalk with white highlights on blue paper, 7 3/4 x 13 in. (20 x 33 cm.)

Pages 64-65: Cat. 38 - *Hippopotamus,* black chalk with white and pink highlights on grey paper, 9 x 13 in. (23 x 33 cm.)

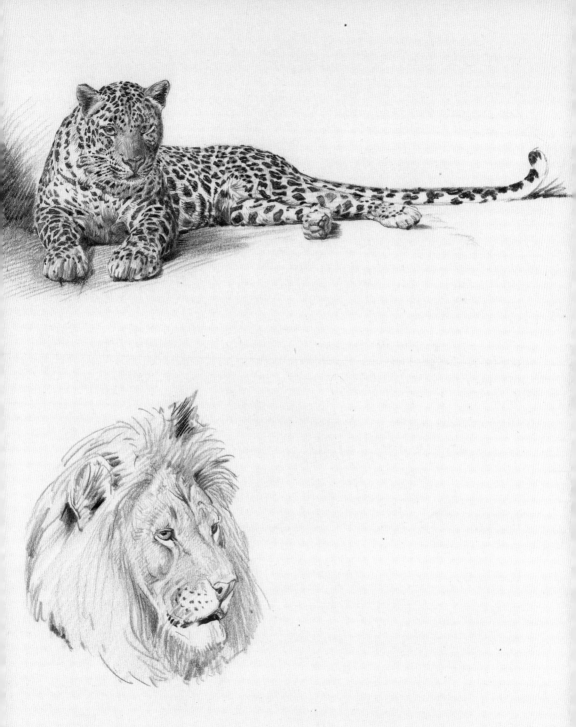

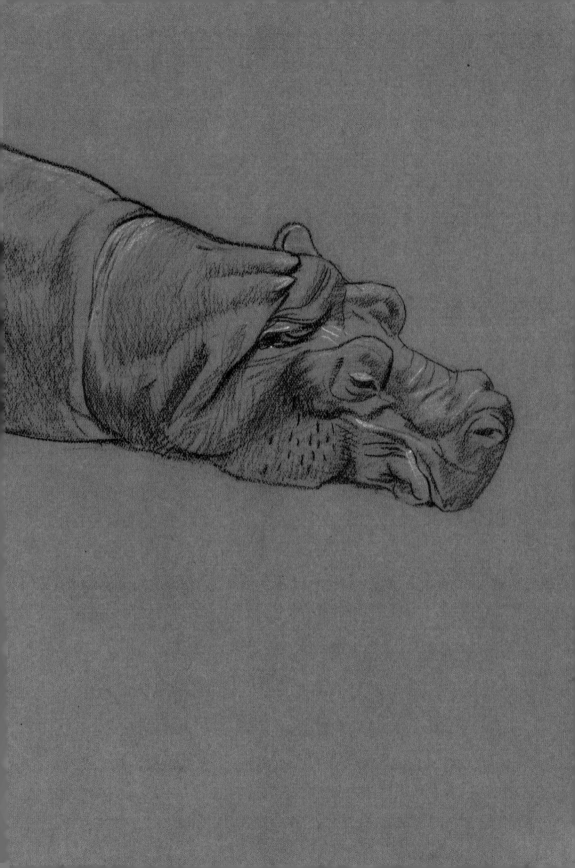

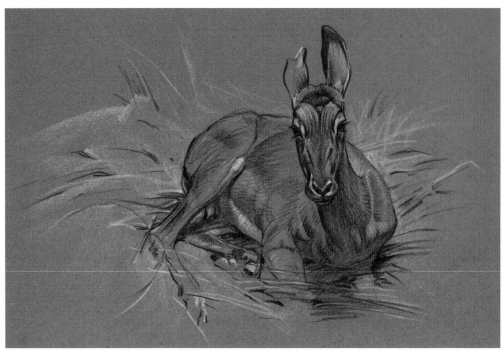

Cat. 39 - *Study of an Impala,* black chalk with white highlights on buff paper, 6 7/8 x 10 1/4 in. (17.5 x 26 cm.)

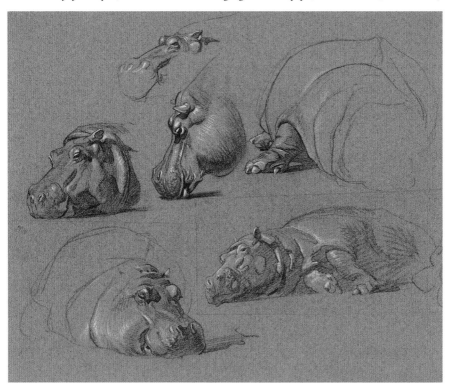

Cat. 40 - *Studies of a Hippopotamus,* black chalk with white highlights on grey paper, 9 7/8 x 12 1/4 in. (25 x 31cm.)

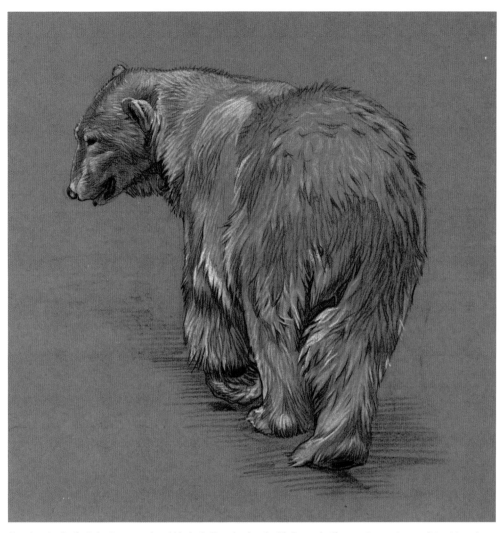

Cat. 41 - *Study of a Polar Bear,* pencil and black chalk with white highlights on buff paper, 8 5/8 x 8 5/8 in. (22 x 22 cm.)

Pages 68-69: Cat. 42 - *Impala,* inscribed with title, coloured chalk on paper, 10 x 15 in. (25.3 x 37 cm.)

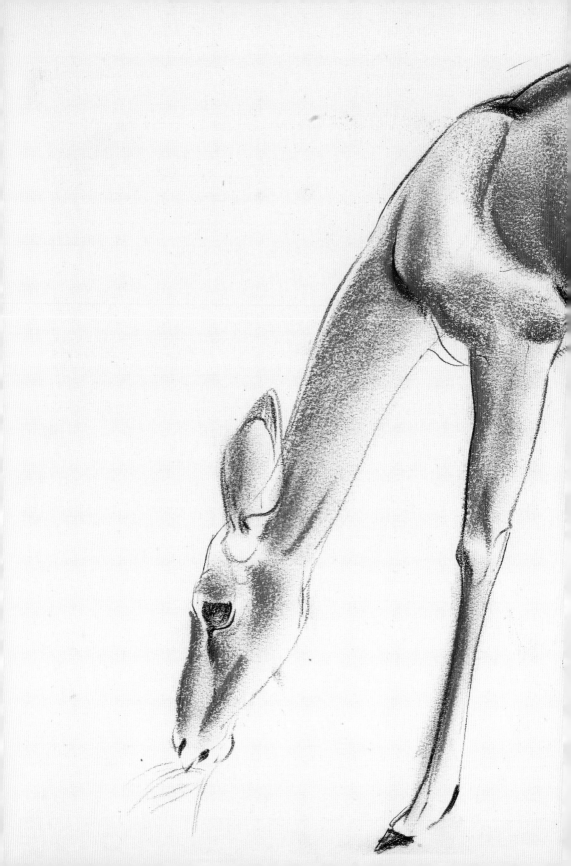

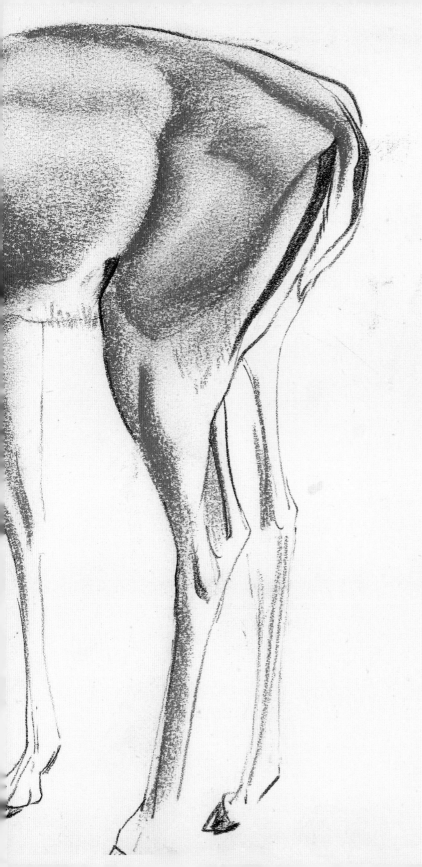

IMPALA

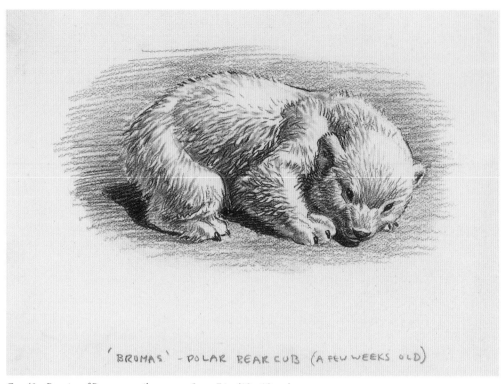

Cat. 43 - *Drawing of Brumas,* pencil on paper, 5 1/8 x 7 in. (13 x 18 cm.)

Brumas was born 27th November 1949. Her mother was named Ivy and her father Mischa. Brumas was named after her keepers Brice and Sam (reversed). She was the first baby polar bear to be successfully reared in Britain and caused such interest that, in 1950, the Zoo's annual attendance figures reached the 3 million mark, (around one million more that usual at the time). This has not been exceeded at any time previously or since. The bear was so popular that newsreels, books, postcards, toys and other souvenirs celebrated her fame. She died on 17th May 1958, the same year as Raymond Sheppard. (*Langford, page 55*)

Pages 72-73: Cat. 46 - *Polar Bears,* signed, pastel on buff coloured paper, 18 x 24 in. (45.7 x 61 cm.)

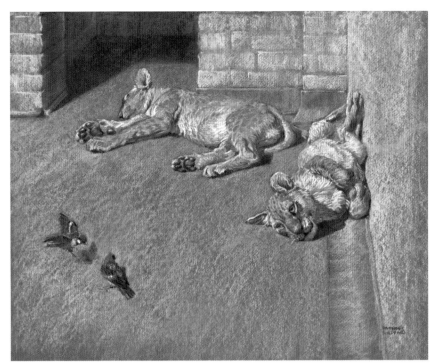

Cat. 44 - *Two Cubs Eyeing Sparrows in London Zoo,* signed, pastel on paper, 15 3/4 x 23 5/8 in. (40 x 60 cm.)

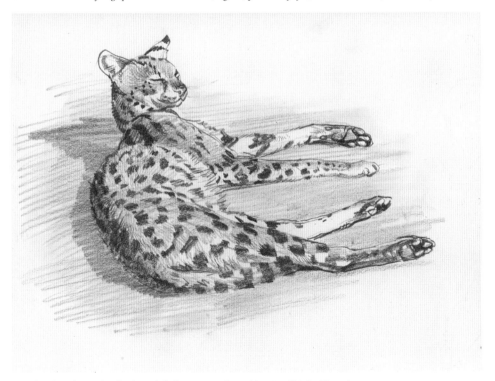

Cat. 45 - *Serval,* pencil and coloured chalk on paper, 9 1/4 x 11 3/4 in. (23.5 x 30 cm.)

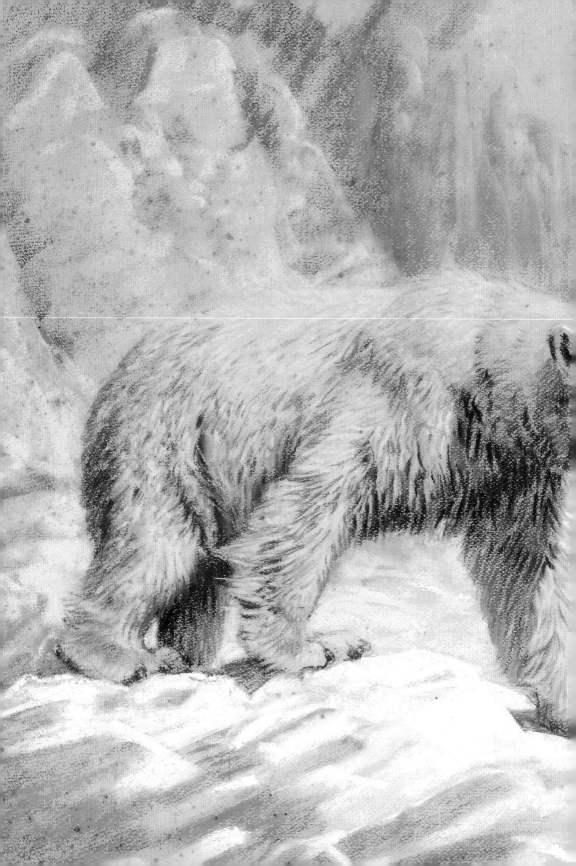

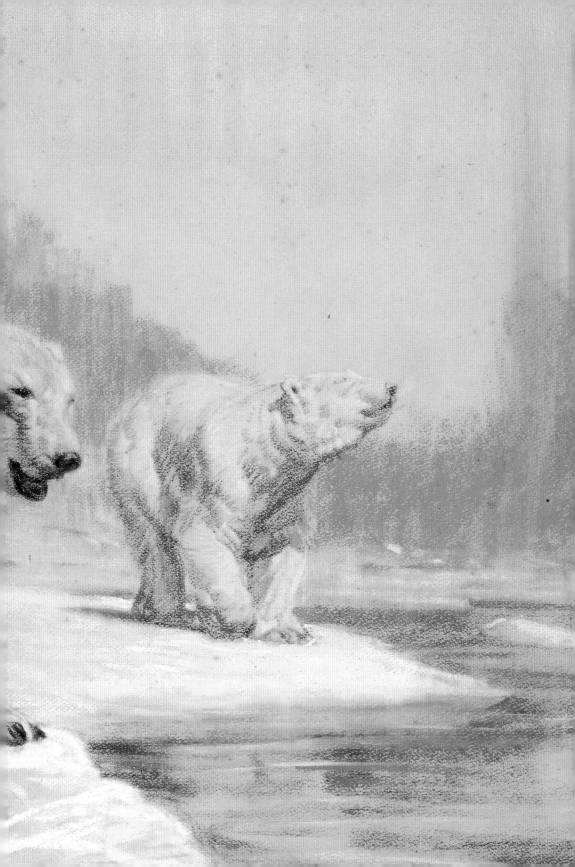

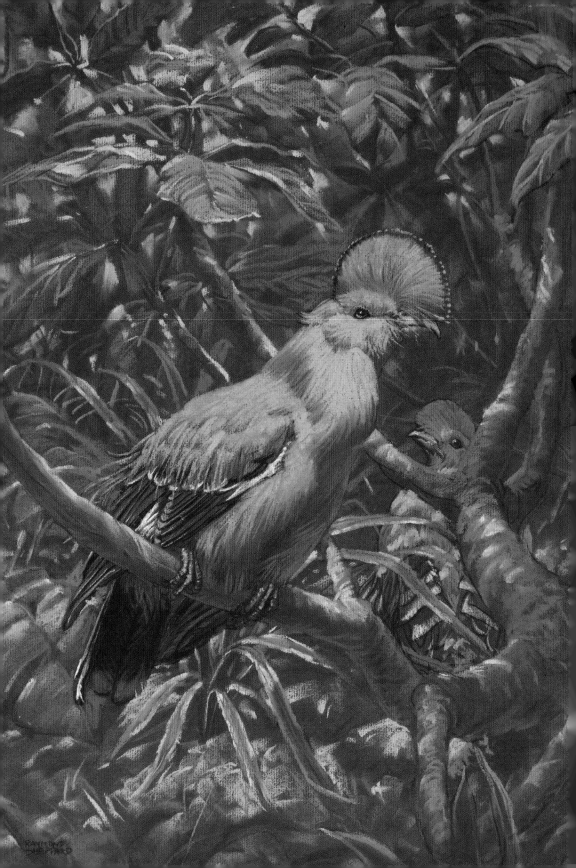

BIRDS

Sheppard adored drawing birds *"...in all their charm and grace of movement, in all their subtlety of line..."* (RS1, page 13). As a young boy he adored making forrays into Scratchwoods in North London where he grew up. On one occasion his sister Nancy recalled him arriving home *"with an injured young rook which he kept in the shed, drew and nursed until it was well again and could be released."* (Christine Sheppard, quoted Langford, page 15)

Drawing birds gave Sheppard a direct link to the tradition of ancient art: *On the temple walls of ancient Egypt you may see carvings and low reliefs of the birds men venerated and worshipped for three thousand years. Ages ago, in China, artists had captured forever on silk, graceful attitude and delicate pattern"* (RS1, page 7).

"It is so exciting trying to get just the right lines, to suggest an attitude or rhythm momentarily observed, be it fluent line of swan or heron, or rugged squareness of the eagle. Art and beauty are so inseparably woven together, and birds are undoubtedly the most perfectly formed of living creatures" (RS1, page 8).

Pages 76-77:
Cat. 48 - *Marabou Storks,* signed, watercolour on paper, 15 3/4 x 23 5/8 in. (40 x 60 cm.)

"My picture of Marabou storks was considered in the first place as a collection of abstract but related shapes whose lines flowed rhythmically one into the other. A danger to be avoided is too much subsequent over-elaboration which may tend to break up the flow of line" (RS2, page 62).

Pages 78-79:
Cat. 49 - *Rooks in a Cage,* signed, watercolour on paper, 6 1/4 x 9 1/2 in. (16 x 24 cm.)

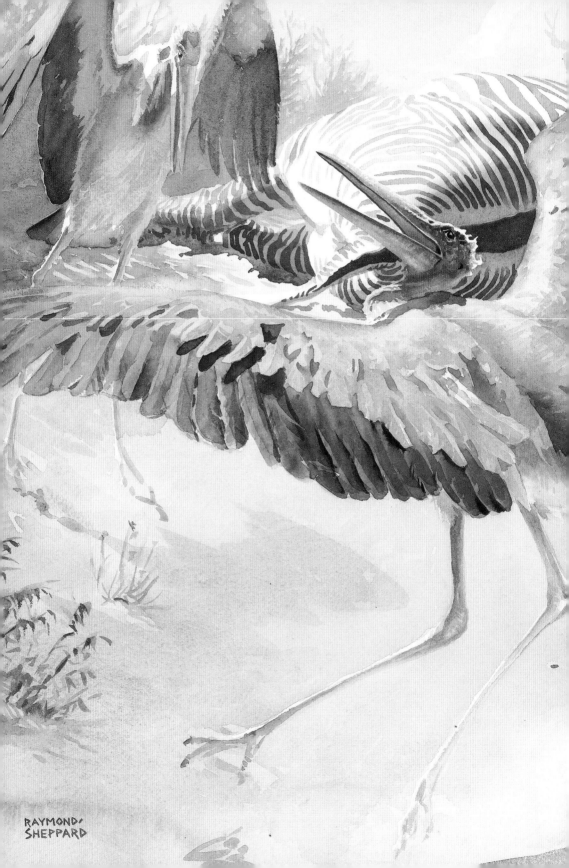

RAYMOND·
SHEPPARD

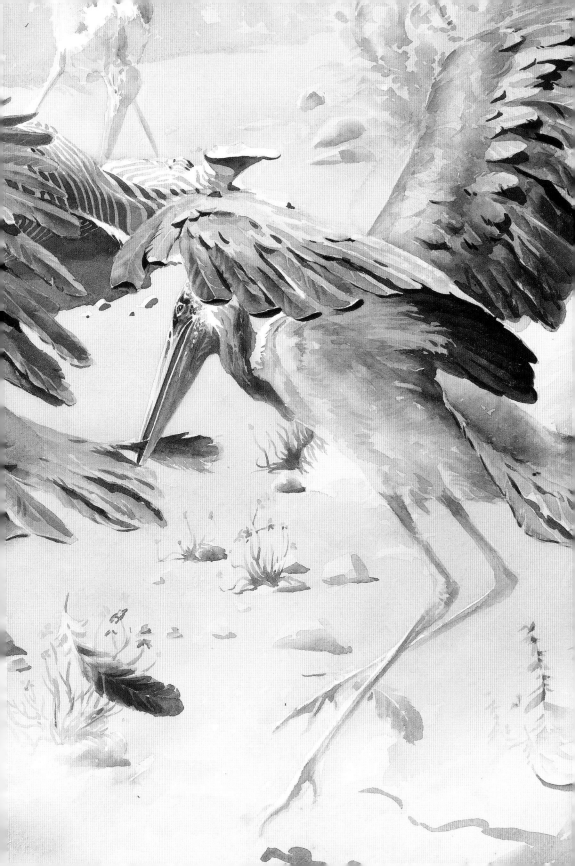

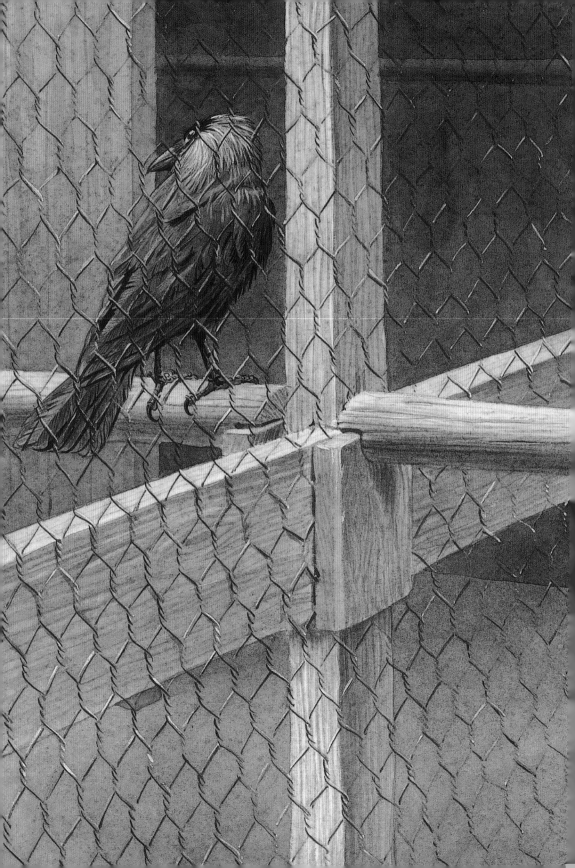

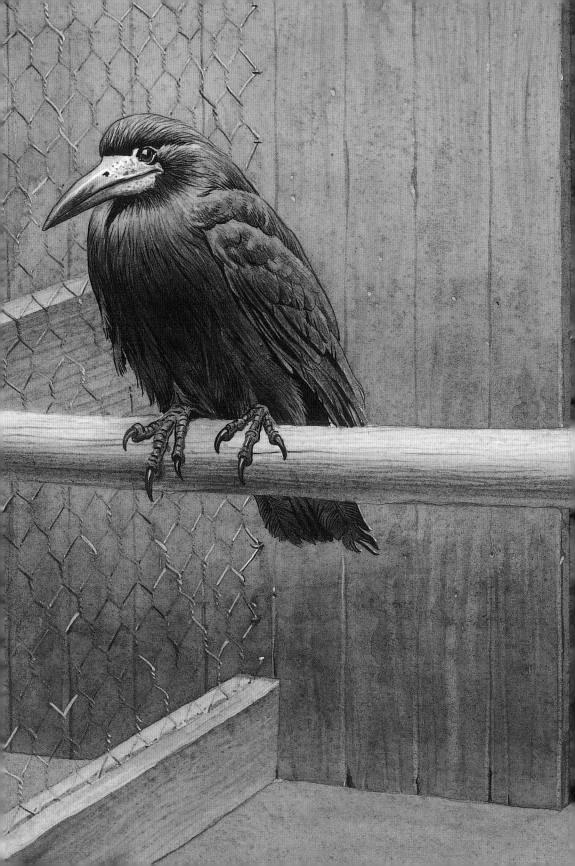

DOMESTIC ANIMALS

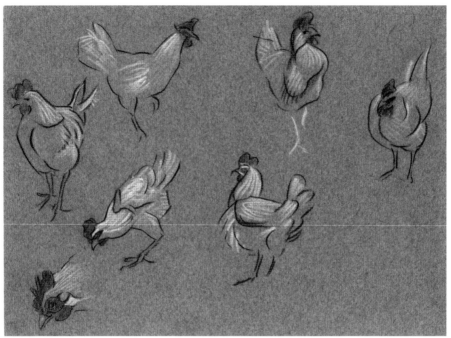

Cat. 50 - *Study of Cockerels,* white, red and black chalk on blue paper, 7 1/2 x 10 1/4 in. (19 x 26 cm.)

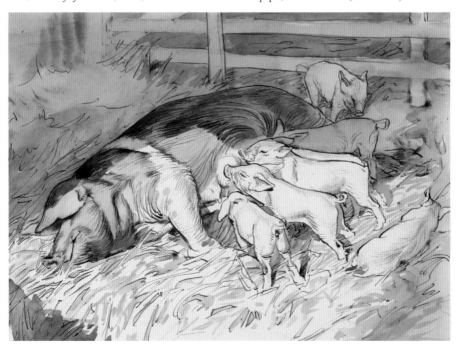

Cat. 51 - *Wessex Saddleback Pig, Overy Farm,* 1944, pen and ink and wash with brown ink highlights on paper, 9 7/8 x 13 3/4 in. (25 x 35 cm.)

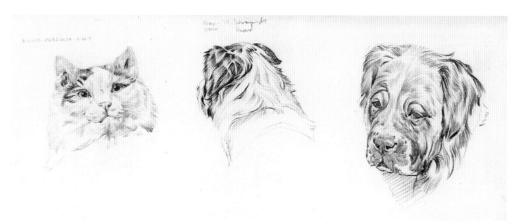

Cat. 52 - *Russo-Persian Cat and St. Bernard,* pencil on paper, 5 1/4 x 13 in. (13.5 x 33cm.)

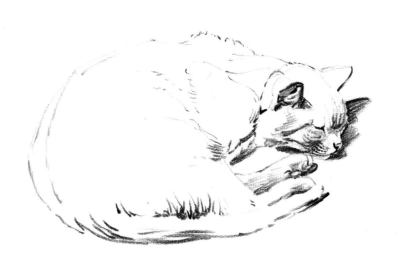

Cat. 53 - *Sleeping Cat,* c. 1950, pencil on paper, 6 1/3 x 8 in. (16 x 20.3 cm.)

Pages 82-83: Cat. 54 - *Donkeys,* pastel on Canson Paper, 18 15/16 x 23 5/8 in. (48 x 60 cm.)

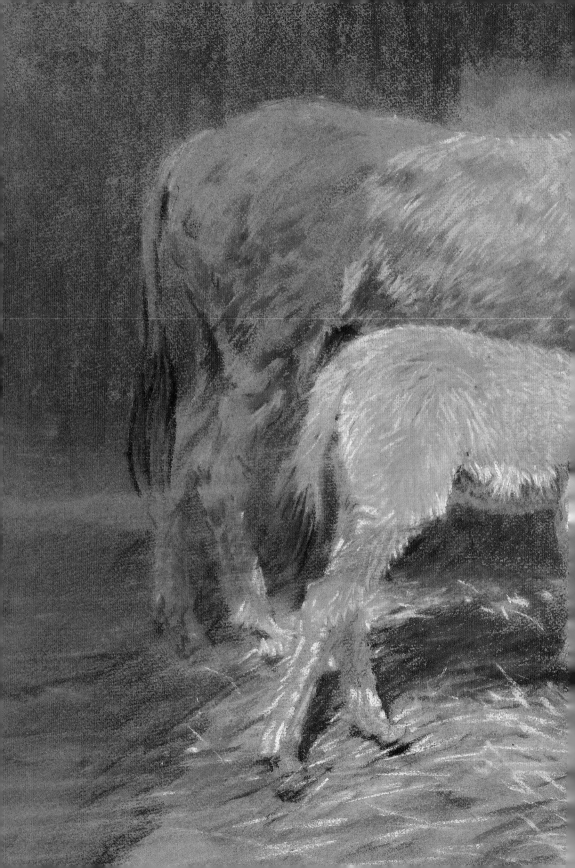

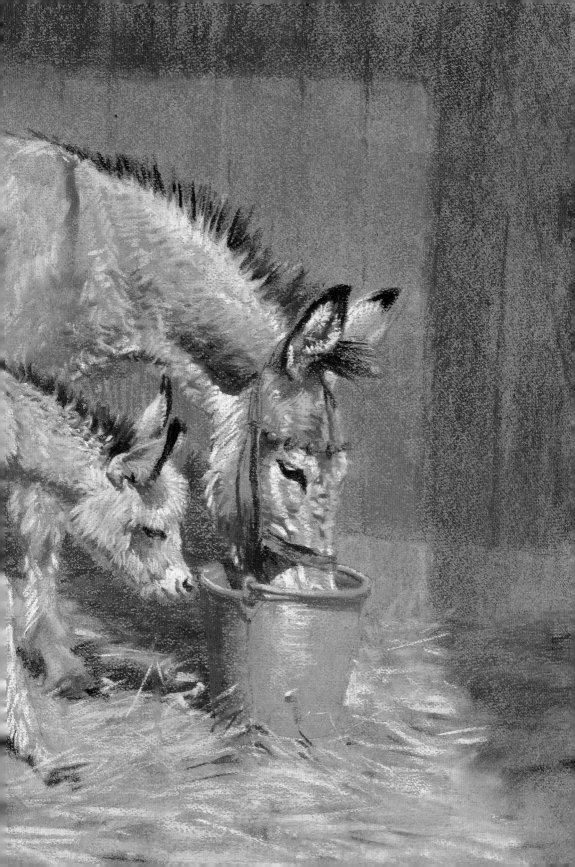

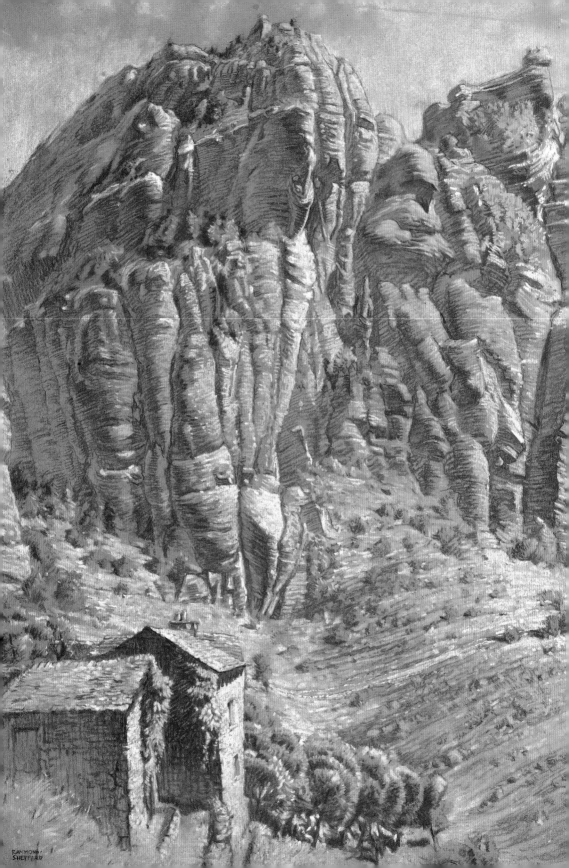

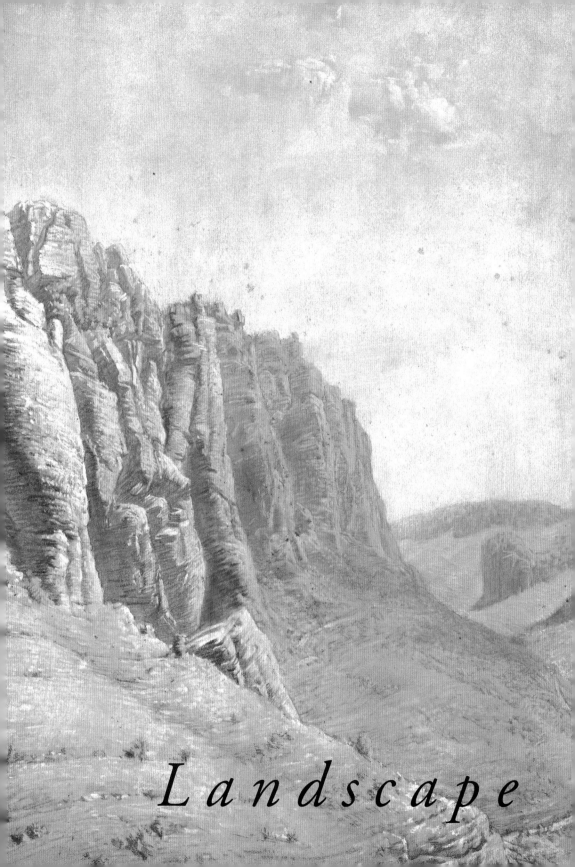

Landscape

LANDSCAPE

Cat. 58 - *Vase de Sèvres, Gorges de la Jonte, Cevennes,* 1945 (Detail)

Raymond Sheppard always carried a sketchbook. The subject matter reflected wherever he happened to be: first and foremost around his locality in North West London – Bushey, Stanmore, Barnet, - and, especially after the purchase of his first car, (a Hillman Minx) in 1954, sometimes further afield: Hertfordshire, Dunstable Downs and the Whipsnade area.

"We often went out into the countryside, usually towards Hertfordshire as we lived in North West London. My father always carried a sketch book, and some days in the summer he would sit and paint whilst we children played or went for a walk with our mother."

As a founder member of the Wapping Group, just before the war, and in the decade which followed it, he painted numerous scenes along the river Thames in the East End of London, (see pages 98 -105). During the war period he sketched whilst off duty in Hertfordshire and Oxfordshire (where he was based during RAF training) and later in the Cevennes, and the la Marne area, where he was stationed as part of the RAF Photographic Reconnaissance Wing during 1945.

Dorset was a regular holiday destination – his parents retired to Christchurch in the 1940s and 2 weeks every summer were spent on holiday in their 2 bedroom bungalow, 53 Kings Avenue.

"For two weeks in the summer holidays we took the train to Christchurch to stay with our paternal grandparents for a bucket and spade traditional seaside holiday. My mother would knit or read, Michael and I would play on the sand and in the shallows of the sea and again, my father would sketch and paint the scenes around."

Family holidays were also taken in rural Norfolk where his wife's parents lived.

Cat. 55 - *Gorges de la Jonte, Cevennes,* 1945, signed, pastel on grey card, 20 x 29 3/4 in. (51 x 75.5 cm.)

Cat. 56 - *Gorges de la Jonte, Cevennes,* 1945, ink and wash on blue paper, 11 x 15 in. (28 x 38.1 cm.) See pages 90-91

Cat. 57 - *The Tarn, France,* c.1944, ink and wash on paper, 10 x 13 7/8 in. (25.5 x 35.5 cm.)

Cat. 58 - *Vase de Sèvres, Gorges de la Jonte, Cevennes,* 1945, ink and wash on paper, 10 3/8 x 14 1/4 in. (26.4 x 36.5 cm.)

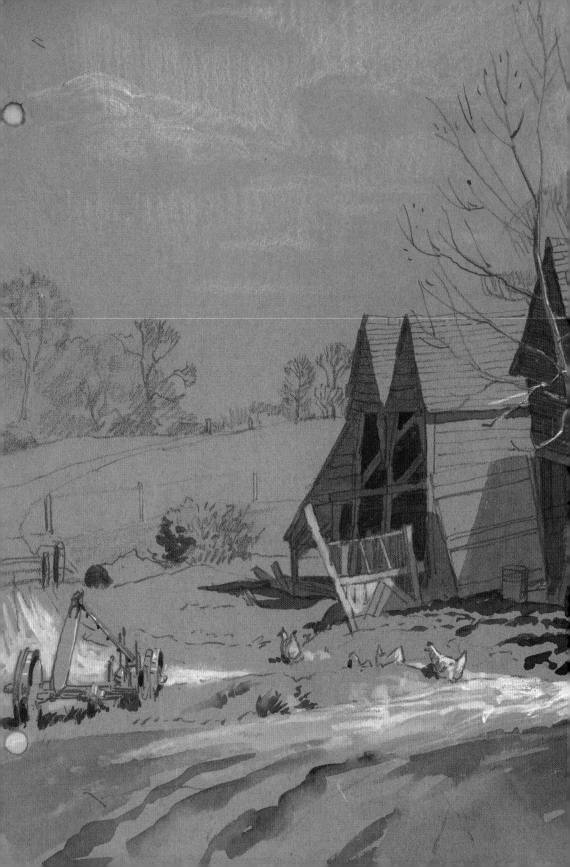

Pages 90-91: Cat. 59 - *A Good Old Fashioned Chicken Farm,* c. 1940, pencil, watercolour, white chalk and white gouache highlights on brown paper, 10 3/8 x 15 in. (26.2 x 38 cm.)

"One of my special memories is of sitting side by side with my father on Hengistbury Head, near Christchurch, Dorset, whilst we both painted a watercolour of the view. I must have been about 8, I think. My brother was with my mother somewhere, the sun was shining and it was warm and balmy. My father mixed up a blue wash and said the first thing to do is to cover your canvas with the blue wash as the sky is in everything. We frequently went there on a small rowing boat ferry with the scary strong currents across from Mudeford Quay."
(Christine Sheppard, email to Paul Liss)

Cat. 60 - *Groynes and Shoreline,* pencil on paper, 5 1/2 x 7 in. (13.7 x 17.5 cm.)

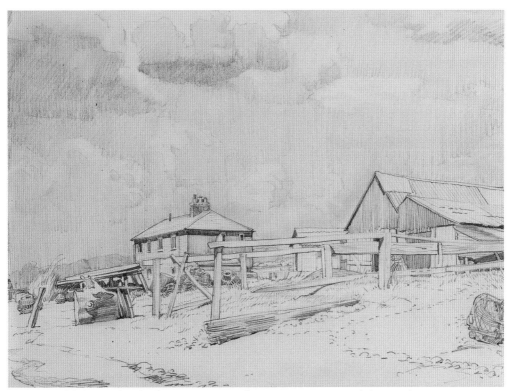

Cat. 61 - *Mudeford, Near Christchurch, Dorset,* 1950s, pencil on paper, 10 1/4 x 13 3/4 in. (26 x 35 cm.)

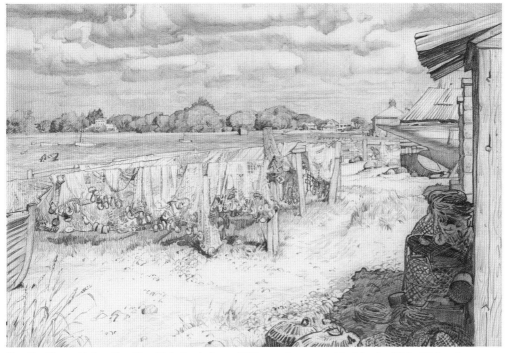

Cat. 62 - *Nets and Lobster Pots, Near Christchurch, Dorset,* 1950s, pencil on paper, 10 x 14 1/4 in. (25.5 x 36.4 cm.)
See pages 94-95

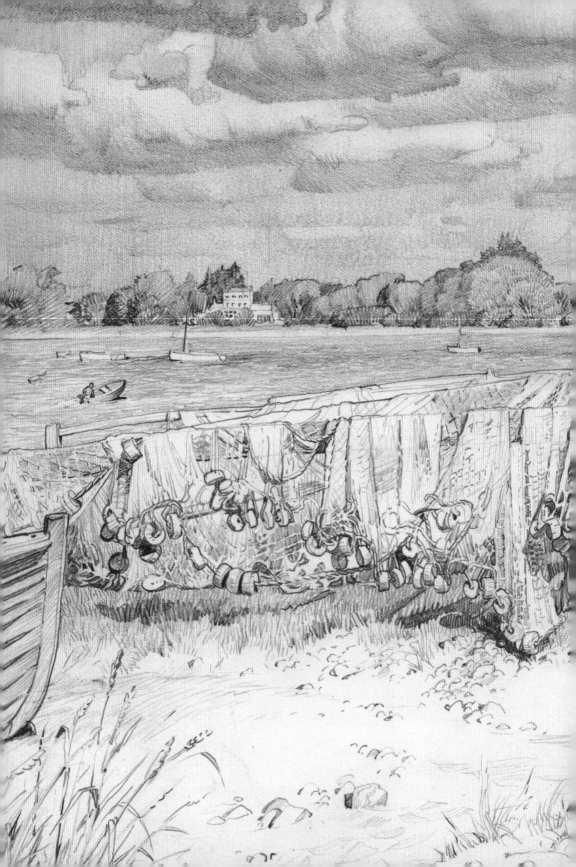

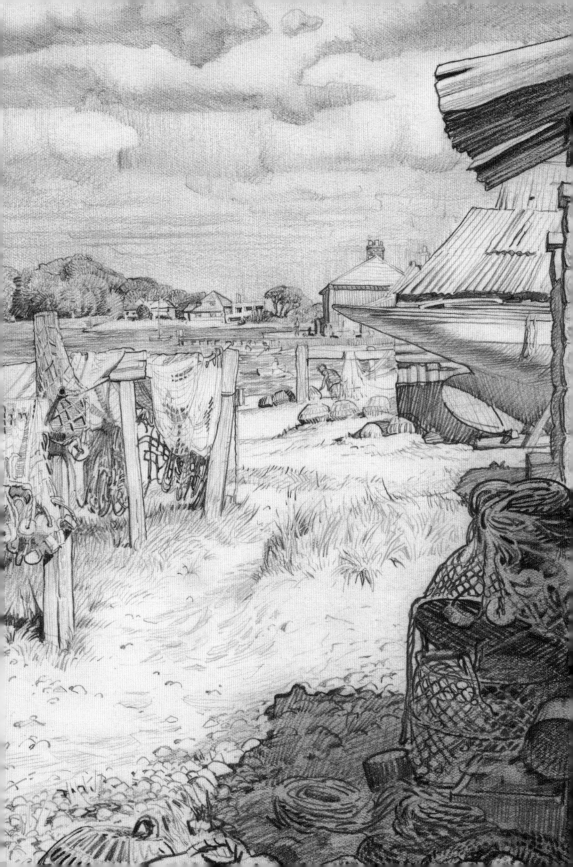

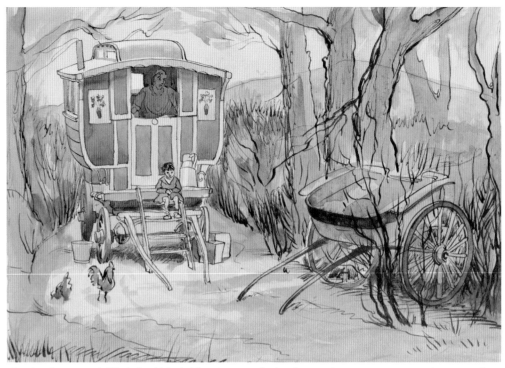

Cat. 63 - *Caravan in the Woods,* dated March 4th 1950, pen and ink and watercolour on paper, 7 x 10 in. (18 x 25 cm.)

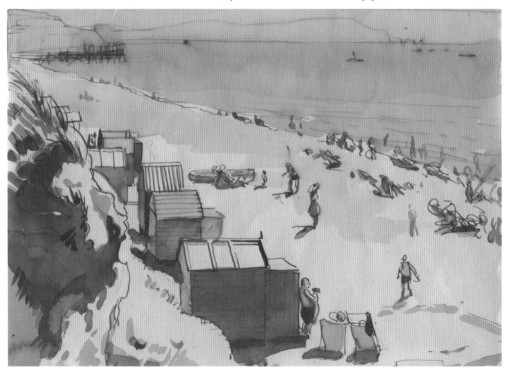

Cat. 64 - *Holiday Huts, Dorset Beach,* watercolour over pen and ink, 7 x 10 in. (18 x 25 cm.)

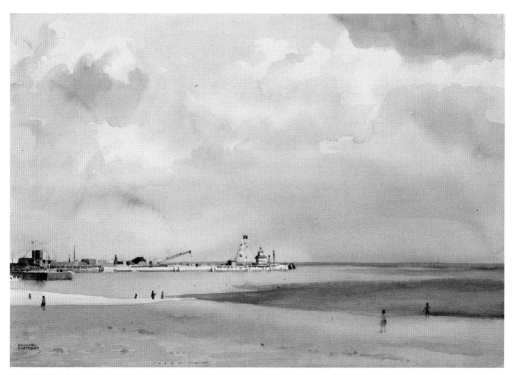

Cat. 65 - *Beach Scene,* late 1930s, signed, watercolour on paper, 10 1/4 x 13 3/4 in. (26 x 35 cm.)

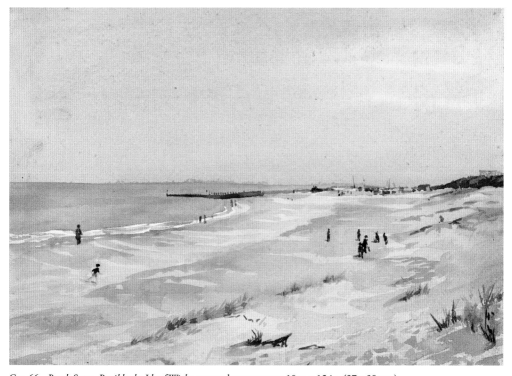

Cat. 66 - *Beach Scene, Possibly the Isle of Wight,* watercolour on paper, 10 5/8 x 15 in. (27 x 38 cm.)

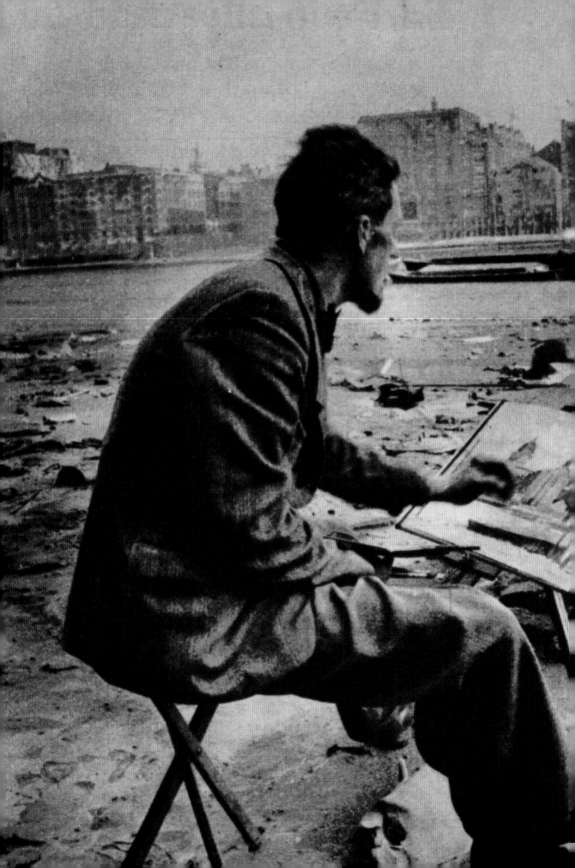

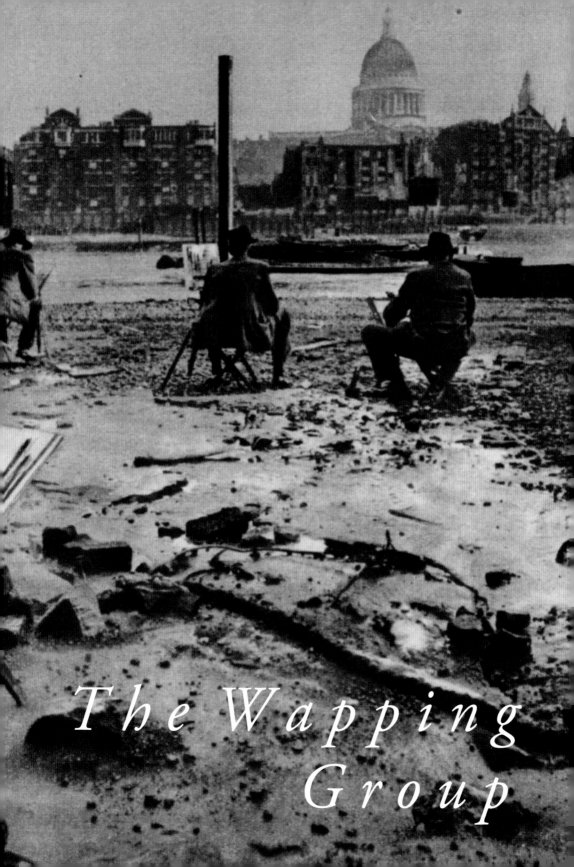

The Wapping
Group

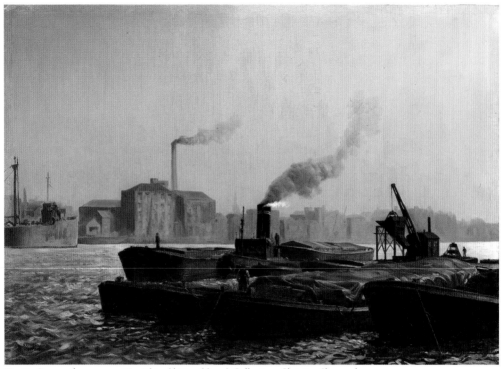

Fig. 5 - *Barges,* oil on canvas, 19 x 26 in. (48.3 x 66 cm.) Collection: Christine Sheppard

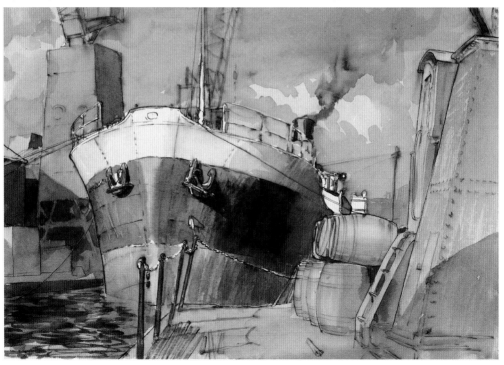

Cat. 67 - *Wapping - Unloading at the Dock,* c. 1950, watercolour on paper, 15 x 22 in. (38 x 56 cm.)

THE WAPPING GROUP

Sheppard was a founder member of the Wapping Group, which began informally in 1939 when members of the Langham Sketch Club, which did not meet in the summer months, decided to reconvene informally by the river at Wapping in the east end of London. In 1946 the Group was officially founded in the pub "The Prospect of Whitby" on the riverfront at Wapping.

There were twenty-one founder members, and the maximum membership at any one time was set at twenty five. Among the leading figures in the beginning were Arthur Burgess, Wilfred Fryer, Jack Merriott, James Middleton, Eric Thorp and William Watkins – all artists of established reputation, many of them senior members of other art societies. The first President was Jack Merriott, with Sir Frank Brangwyn as Honorary Vice President.

An inaugural supper was held at "The Prospect of Whitby" on May 16th, 1947 and later in the year the first exhibition took place at the Port of London Authority headquarters on Tower Hill. Opened by the writer A. P. Herbert, the exhibition brought the Wapping Group to public notice and enjoyed much support from shipping and marine insurance interests in the City. It was also the subject of a special article in the August 16th, 1947 issue of *Picture Post*.

Pages 102-103:
Cat. 68 - *Cruise Boat and Sail Boat at Wapping*, c. 1930, signed, oil on "Dalston" canvas board, 12 x 16 in. (30.5 x 40.5 cm.)

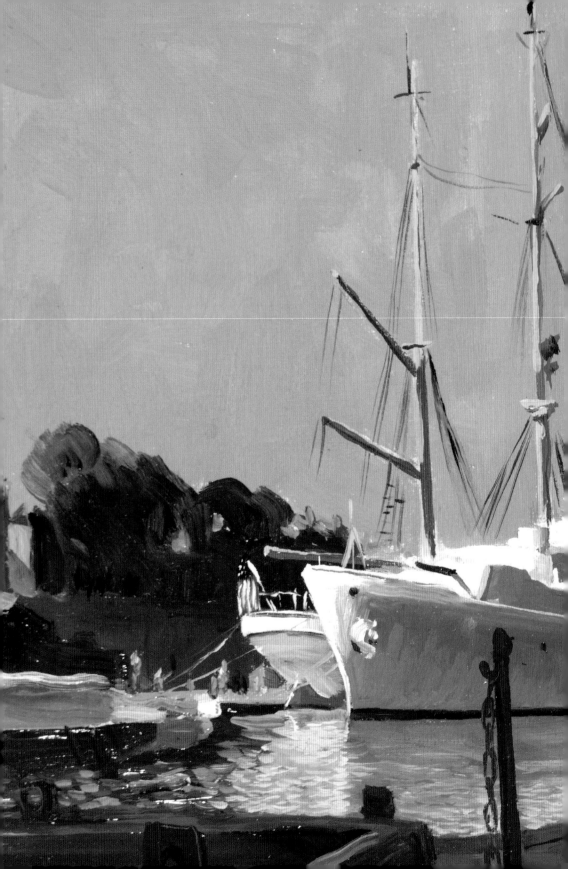

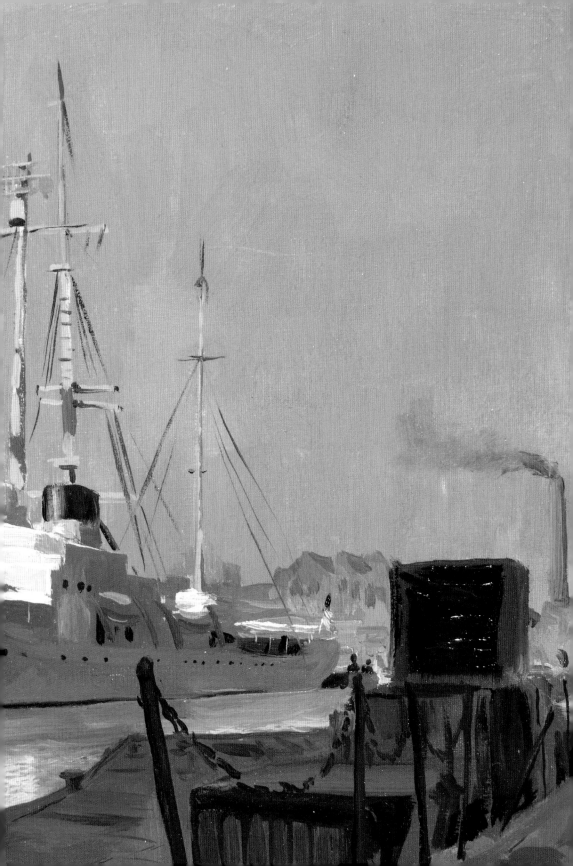

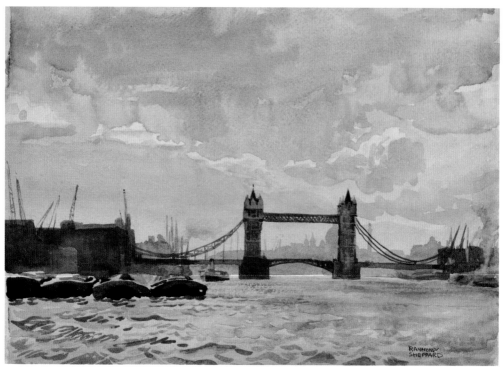

Fig. 6 - *Tower Bridge,* watercolour on paper, 11 1/2 x 15 in. (29.2 x 38 cm.) Collection: Christine Sheppard

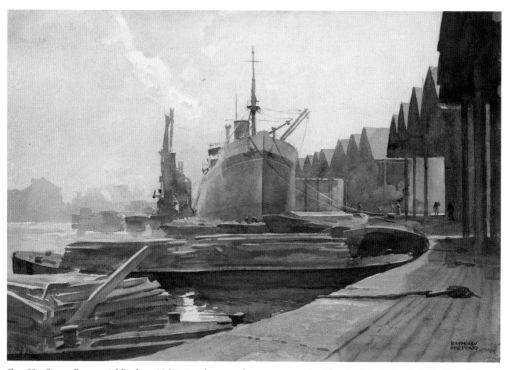

Cat. 69 - *Surrey Commercial Docks,* c. 1940, signed, watercolour on paper, 15 x 20 1/2 in. (38 x 52 cm.) Right: Detail

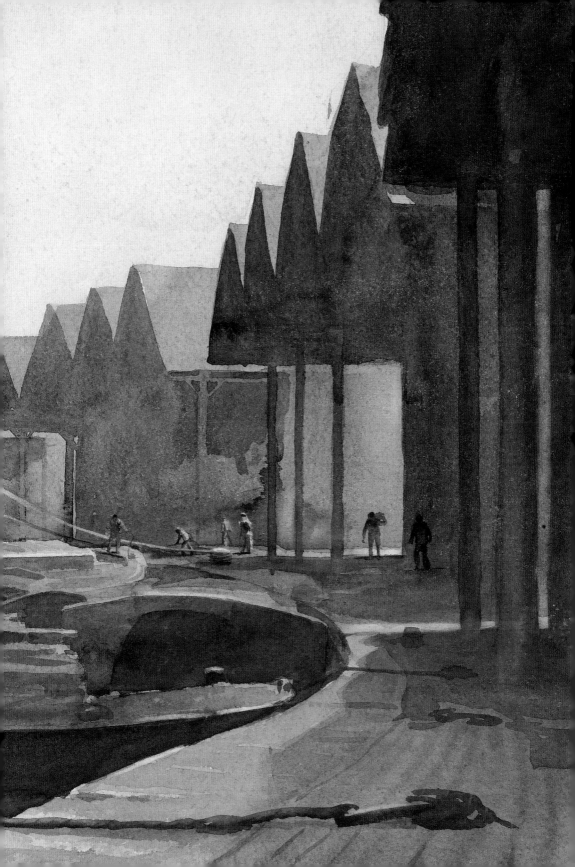

War

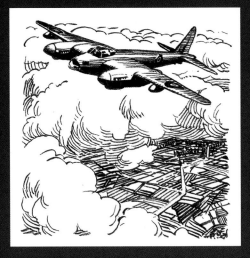

Cat. 70 - *High Level Aerial Photos,* c. 1957, inscribed with title in pencil, pen and ink on paper, 3 1/2 x 3 3/8 in. (9 x 8.5 cm.)

This image, along with Cat. 71 and Cat. 72, appeared in Lilliput, (vol 41:4), October 1957, Operation Jericho by Sandy Sanderson

Cat. 71 - *Crash in Flames,* c. 1957, inscribed with title in pencil, pen and ink on paper, 3 1/2 x 3 3/8 in. (9 x 8.5 cm.)

Cat. 72 - *A Speeding Train Hurled into Another...,* c. 1957, inscribed with title in pencil, pen and ink on paper, 3 1/2 x 3 3/8 in. (9 x 8.5 cm.)

WAR

Born a year before WW1 commenced Sheppard's earliest memories were of its direct aftermath. In the Second World War he served in the RAF. As such, both wars informed his work and in the illustrations he did for magazines such as *Lilliput*, in the 1950s, he revelled in a boy's-own vision where exploding bombs, burning aircraft and torpedoed ships were merely exciting compositional devices far removed from the horror of real war.

Aeroplanes were a subject that naturally appealed to Sheppard – the flight of birds was something he had already studied in depth and Sheppard associated the two subjects in his mind:

"...we have heard such a lot recently [about] *"protective colouration" which merges itself into the bird's natural background of rushes, grass or stones, and as long as the bird is motionless it is invisible to its enemies. I expect our camouflage experts have learnt a lot from the study of these protective patterns and colours of birds"* (RS1, page 5).

"...men who design aeroplanes have been studying the shape and flow of lines of a bird, which they call its streamline, and they have tried to adapt these shapes to the designs because they know that birds are the most perfectly streamlined creatures in the world..... Throw a piece of bread in the air and he swoops with the precision of a Spitfire" (RS1, page 6).

In October 1940 Sheppard joined the RAF. He was initially selected for aircrew training but was declared medically unfit and served instead as Leading Aircraftman at RAF Benson. In 1943 he was posted to No 76 Squadron and subsequently he was placed for training with No 1. School of Photography at Farnborough, based near Marlow with the photographer Andrew Carr.

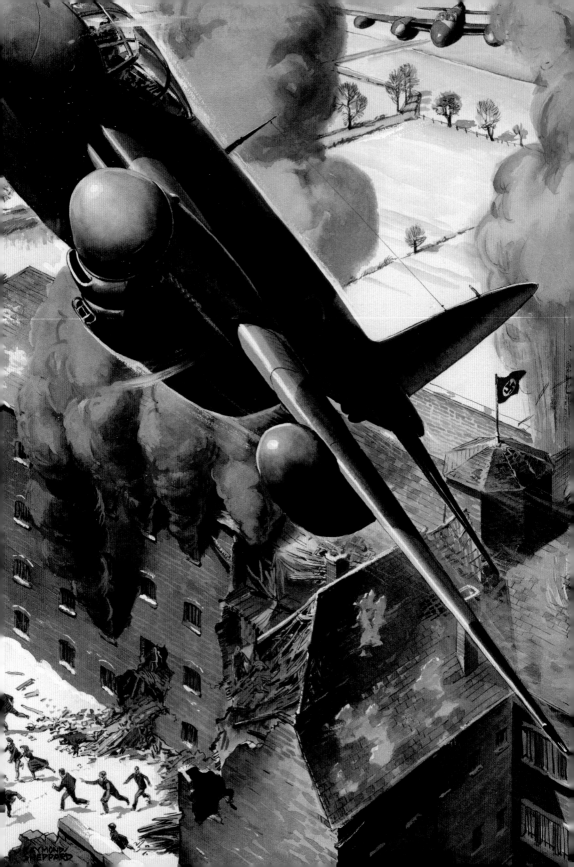

Barbara Carr recalls that her husband and Raymond Sheppard *"would take leave together, hitch-hiking home to London. If they had a pass stamped and signed they got free rail pass for 48 hour leave. But they were not supposed to leave the Camp without that leave pass. RS appropriated two and forged the stamp by drawing the rubber stamp and all the faded bits and the warrant officer's signature so they could leave the Camp and travel home to see us! Iris and I were terrified they'd get picked up by the police. In this day and age it wouldn't have mattered at all but during the War this was a serious offence….. Service life did not agree with Raymond, he didn't like it. Too free a spirit"* (Langford, page 18).

In 1945 Sheppard was assigned to the RAF Photographic Reconnaissance Wing and sent to Coulommiers (east of Paris). Whilst off duty Sheppard made sketching trips to the Cevennes, Ardèche and Dordogne regions. Inscriptions on drawings from this period identify locations as Coulommiers, and Orgnac-l'Aven.

Cat. 73 - *Airfield*, c.1940, signed, pencil on paper, 6 1/2 x 9 in. (16.5 x 23 cm.)

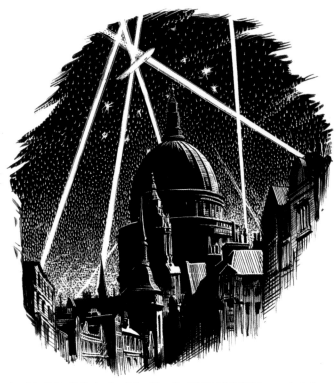

Cat. 76 - *End of a Sea Raider*, c. 1957, signed, gouache on card, 16 x 12 in. (30 x 28 cm.)

Cat. 74 - *St Paul's Under Attack frm Zeppelin LZ-38 1915,* 1957, extensively inscribed with printing instructions, pen and ink on board prepared with gesso, 9 1/2 × 7 7/8 in. (24 × 20 cm)

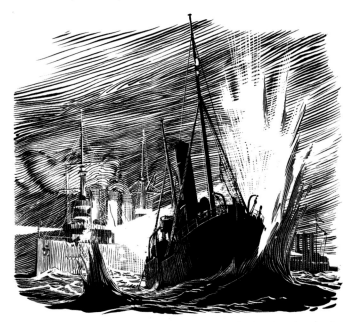

Cat. 75 - *Attack on the Fleet,* inscribed with title, pen and ink on board prepared with gesso, 9 1/8 x 10 1/2 in. (23 x 27 cm)

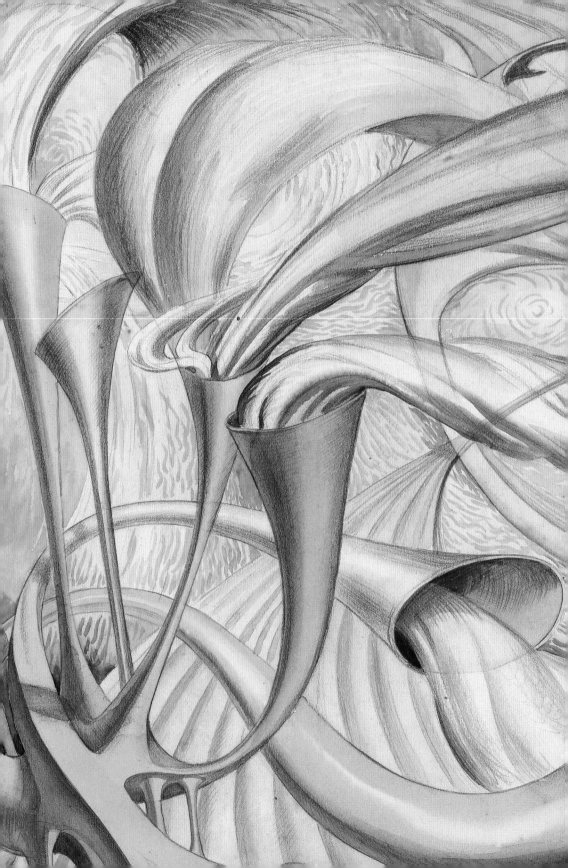

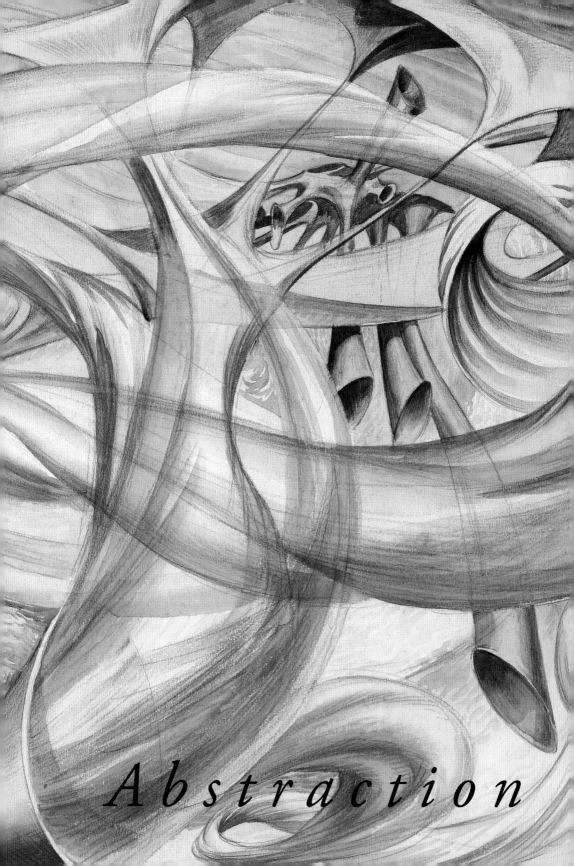

Abstraction

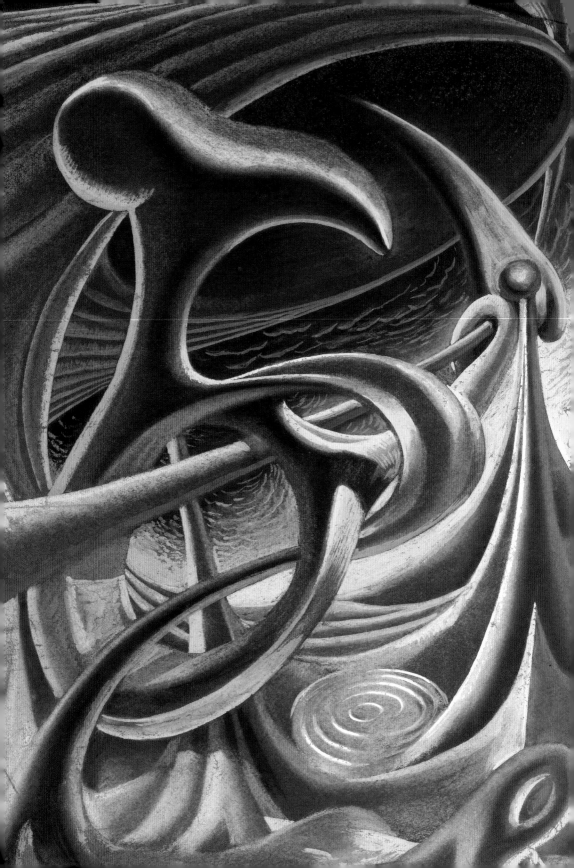

ABSTRACTION

For an artist who otherwise excelled in drawing life around him Raymond Sheppard's abstract compositions come, at first sight, as a surprise. On further acquaintance, however, far from representing a break with his main oeuvre, these works might be seen as a logical consequence of his approach to art. Of drawing birds, for instance, he commented:

"I think the real reason I like so much drawing birds is not entirely because I am so interested in their lives and actions, but more so because the innumerable patterns I can make out of their so varied and graceful movements, the limitless groupings, arrangements and placing of curves and lines and shapes that arise from their ever-varying postures" (RS1, page 8).

He recommended to students that *"...when composing groups of animals or bird there must (above all) be a flow of line to knit the units together"* (RS2, page 61). *"It is a good thing to let yourself go and experiment ... if you like, try abstracting pattern alone from the animals"* (RS2, page 63).

A fascination with Marine life also played a part in Sheppard abstracts: *".... the wonderful creatures to be seen in the aquarium. What lovely patterns they make. There are many more for you to enjoy in this enchanted underwater world"* (RS2, page 60).

Likewise his experience as a reconnaissance photographer during the war is likely to have informed these works as well a general

admiration for Oriental art; both taught Sheppard the possibilities of abandoning conventional perspectives and of exploring space differently.

Sheppard's earlier interest in Surreal art equally informed his abstract pictures, as possibly did the work of contemporary artists such as Edward Burra or William Baillie. Arguably amongst his most original and engaging works these pictures mark the point at which all of his interests merged and he gave free reign to his imagination and feeling. In a revealing (and somewhat out of context) paragraph in *How to Draw Birds* the artist states:

" *'Imagination' (is the quality that) 'unconsciously' should above all show in a drawing and make it a work of art, a thing of beauty. 'Feeling' (is) that peculiar, unexplainable tightening inside that makes you want to laugh sometimes, sometimes to sing and dance for joy, and sometimes just a little sad…. is the most important thing of all to cherish. Rush out into the sunshine – Art does not grow in dusty rooms. No, it is under the great arch of heaven in the pure and sparkling air, through which on wondrous pinions fly the birds we draw, and you in your imagination can fly with them into what unknown and pleasant regions of the mind, to that perfection of Beauty towards which all art aspires*" (*RS1, page 16*).

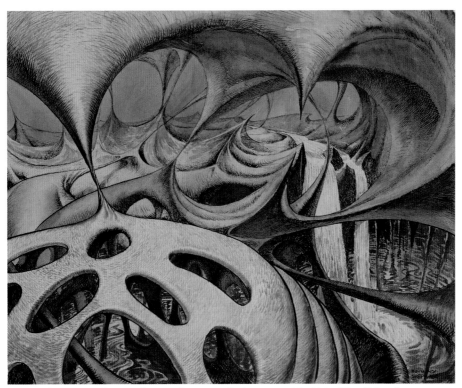

Cat. 78 - *Sea Form*s, 1940s, signed, watercolour pen and ink on paper, 15 x 18 in. (38 x 45.8 cm.)

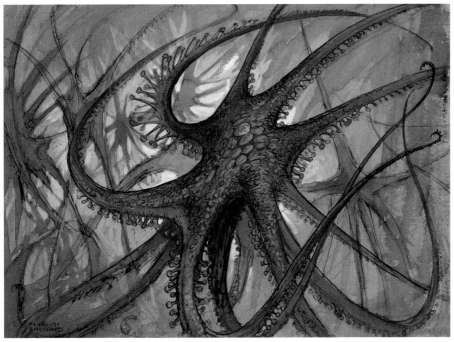

Cat. 79 - *Marine Forms,* 1940s, signed, pen ink and watercolour with highlights in blue on light blue paper,
9 7/8 x 13 3/4 in. (25 x 35 cm.)

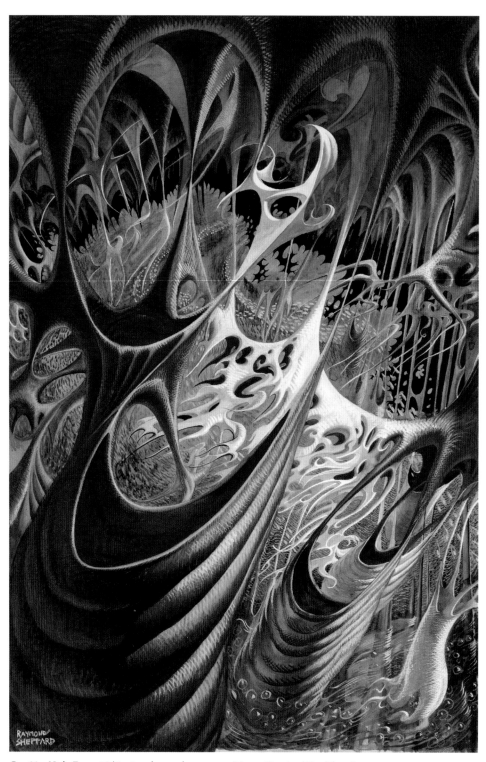

Cat. 80 - *Night Forms*, 1940s, signed, gouache on paper, 20 1/2 x 13 3/8 in. (52 x 34 cm.)

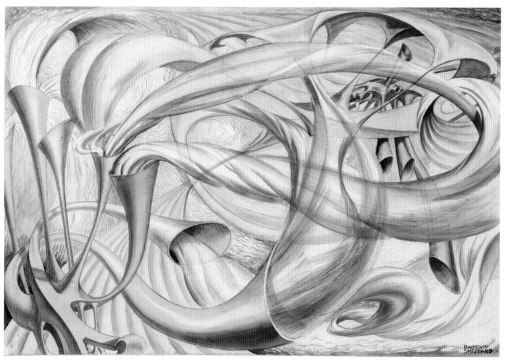

Cat. 81 - *Dream Forms,* c. 1940, signed, gouache on paper, 15 x 22 in. (38 x 55.8 cm.)

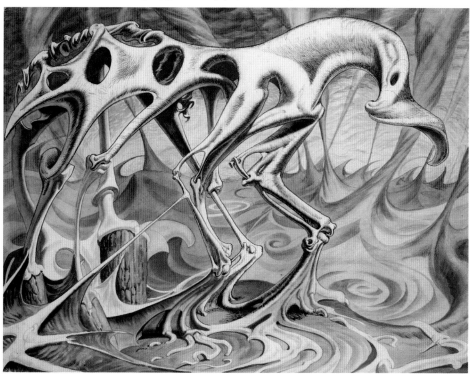

Cat. 82 - *Primeval Forms,* 1940s, gouache on paper, 22 5/8 x 28 3/4 in. (55 x 73 cm.)

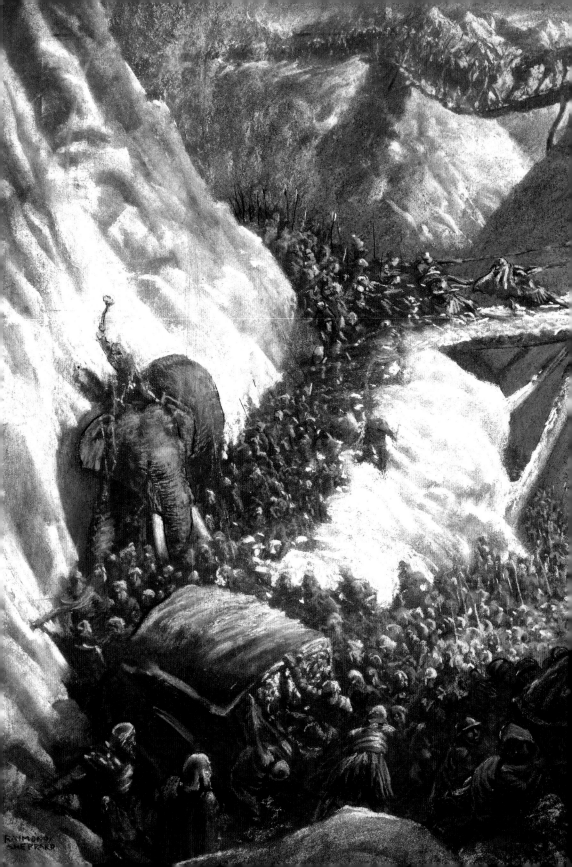

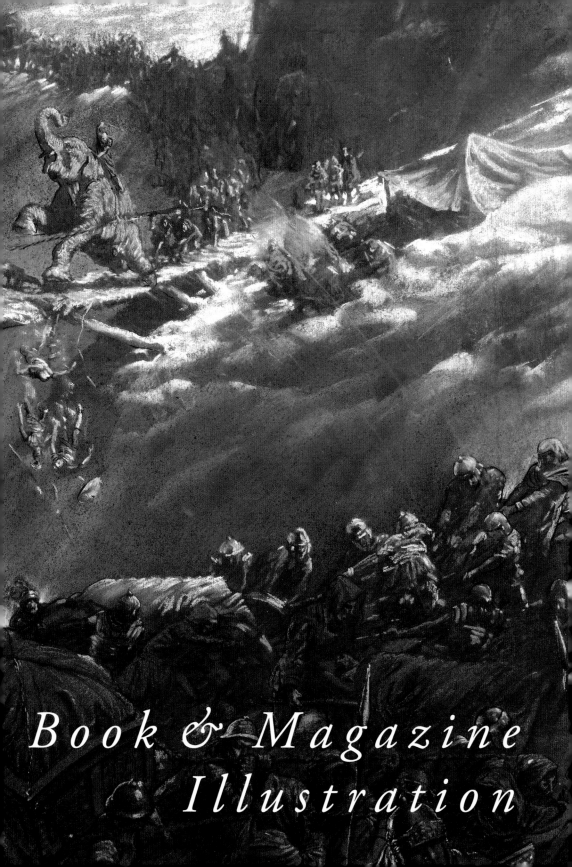

Book & Magazine
Illustration

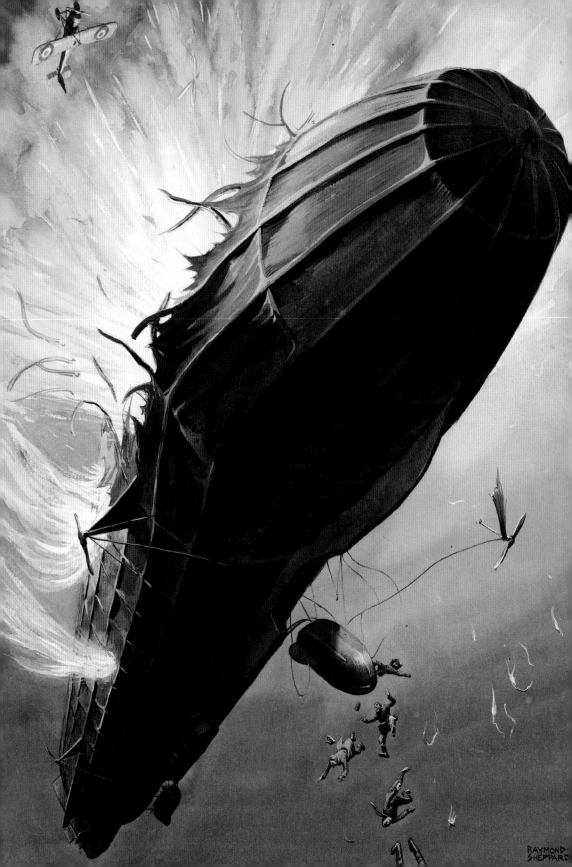

BOOK & MAGAZINE ILLUSTRATION

Between 1934 and 1958 Sheppard illustrated well over 100 books. The majority of these date from the 1950's when Sheppard was often illustrating as many as ten a year – a prodigious rate tragically cut short by his death at the age of 45. Commissions from over fifteen publishing houses (Hutchinson, Blackie and Son, Macmillan, Oxford University Press, Faber and Faber) included illustrations for leading authors of the day such as Enid Blyton, (two books in 1948 as well contributing to a regular annual she wrote all the stories for), Jim Corbett (six titles between 1947 and 1955) and, perhaps most notable of all, a commission in 1952 (shared with Tunnicliffe) to illustrate Ernest Hemingway's *The Old Man and the Sea.*

Equally successful was Sheppard's career as an illustrator for comics such as *Eagle, Girl,* and *Swift,* and magazines such as *Boy's Own Paper, Lilliput, Everbody's, Picture Post,* and *Reynolds News. Lilliput* was founded in 1937 by Stefan Lorant , (the photo journalist who later created *Picture Post*), with a subtitle of *"The Pocket Magazine for Everyone."* Its original size was allegedly such that it could be slipped into a soldier's trenchcoat and was no doubt read in many an air-raid shelter in that handy size. During its 23 year run the magazine contained the illustrations of Mervyn Peake, Eric Fraser, Frank Bellamy (of Dan Dare fame) and, perhaps most famously, Ronald Searle's cartoon series St. Trinians. The magazine became known for its photographs too, with work by Brassai, Zoltan Glass and also Bill Brandt. The magazine subtitle was changed in September 1954 to *"Lilliput is a Man's Magazine"* . From a starting position of 216,562 in 1938 - double that of *Punch* at the time - by May 1959 *Lilliput* was only selling circa102,000 copies - number 277, July 1960, was the last issue at which point it was merged with *Men Only.*

Everybody's, a weekly magazine, began life as *Competitor's Journal* in 1913. After achieving sales pre-World War Two of 798,878 it went past the million mark (at the time *Radio Times* – always historically the bestselling weekly in the UK - sold 6,992,046 (1948). During its run many famous illustrators and comic artists produced work including Fortunino Matania, Frank Bellamy, Eric Fraser, Leslie Caswell, and Peter Jackson. Its large format, similar to *Picture Post*, together with the use of photogravure printing, allowed for the illustrations to carry particularly good reproduction in detail. In 1959 *Everybody's* was absorbed into the long running *John Bull*.

For *Boy's Own Paper* Sheppard produced a long run of illustrations in the 40s and 50s. The origins of *Boy's Own Paper* were as a weekly paper aimed squarely at a young male audience. Tales of derring-do, scientific articles, do-it-yourself and fictional pieces by many well known authors were standard contents until 1967 when it ceased publication. The run adds up to a legend in British publishing – 2511 issues all told. During the wars *Boy's Own Paper* remained, as would be expected extremely patriotic highlighting the sacrifice of the troops abroad. The Biggles author Captain W.E. Johns wrote stories during the 50s. *The Boy's Own Paper* must have had a special relationship with Sheppard as an obituary was published to accompany his last illustration for the magazine in June 1958.

Sheppard's work unusually appeared in *Picture Post,* a magazine known for its photographic journalism. During the years 1950 through to the end of its run in June 1957 Sheppard was the only person asked to illustrate a story.

According to Norman Boyd, Sheppard contributed to at least 68 issues of *Lilliput*, 36 issues of *Boy's Own Paper*, 32 of *Everybody's*, 14 of *Young Elizabethan*, and 11 of *Picture Post* (not counting advertisements). Additionally he contributed to other publications including at least18 assorted Annuals such as *Watch with Mother!* and weekly comic panels and strips, for instance for *Eagle, Girl* and *Swift*; also school display posters and other design work such as the cover for ICI's booklet *"Prevention of Mastitis in Dairy Herds"*.

Cat. 84 - *The Great Flight*, 1952, pen and ink over gouache on paper, 5 1/2 x 4 1/2 in. (14 x 11.5 cm.)
From *Picture Post*, January 26th 1952

Whilst a portion of his oeuvre remains constrained by the period charm and melodrama of the era to which it belongs, many of the illustrations combine Sheppard's greatest strengths: a technical virtuosity which belies a deep understanding and appreciation of Japanese prints and a natural flair for surreal juxtaposition.

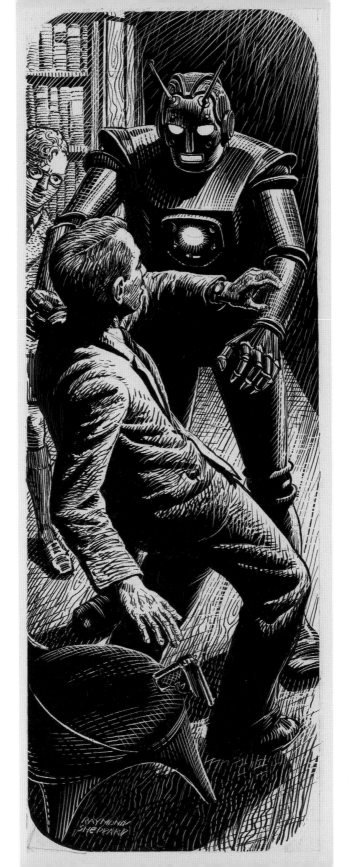

Cat. 85 - *Leave it to Jones,* 1956, pen and ink on gesso prepared board, 13 3/4 x 5 3/4 in. (35 x 14.5 cm.)

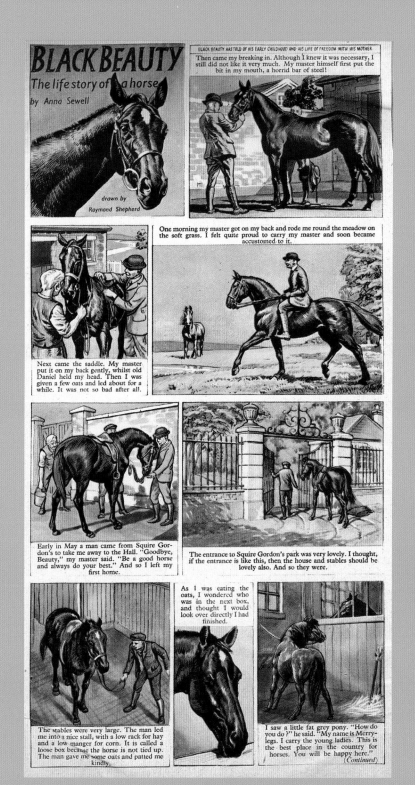

Fig. 8 - Comic strip illustrations for *Black Beauty*, from *Girl*, published by Hulton Press

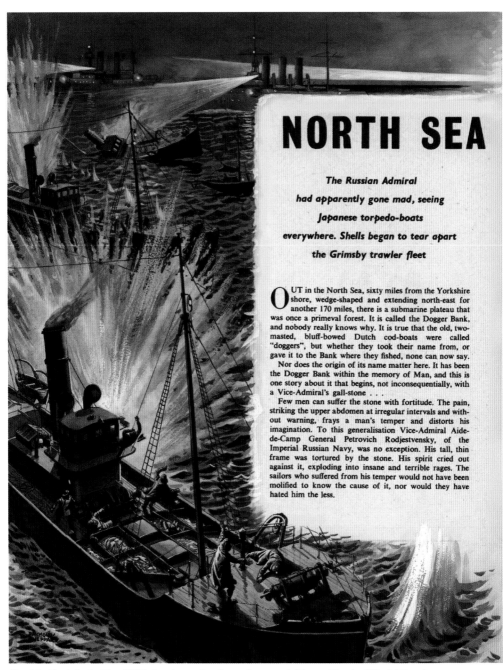

NORTH SEA

The Russian Admiral

had apparently gone mad, seeing

Japanese torpedo-boats

everywhere. Shells began to tear apart

the Grimsby trawler fleet

OUT in the North Sea, sixty miles from the Yorkshire shore, wedge-shaped and extending north-east for another 170 miles, there is a submarine plateau that was once a primeval forest. It is called the Dogger Bank, and nobody really knows why. It is true that the old, two-masted, bluff-bowed Dutch cod-boats were called "doggers", but whether they took their name from, or gave it to the Bank where they fished, none can now say.

Nor does the origin of its name matter here. It has been the Dogger Bank within the memory of Man, and this is one story about it that begins, not inconsequentially, with a Vice-Admiral's gall-stone . . .

Few men can suffer the stone with fortitude. The pain, striking the upper abdomen at irregular intervals and without warning, frays a man's temper and distorts his imagination. To this generalisation Vice-Admiral Aide-de-Camp General Petrovich Rodjestvensky, of the Imperial Russian Navy, was no exception. His tall, thin frame was tortured by the stone. His spirit cried out against it, exploding into insane and terrible rages. The sailors who suffered from his temper would not have been molified to know the cause of it, nor would they have hated him the less.

Cat. 86 - *North Sea Incident*, 1957, signed, pencil and gouache on card, 17 3/8 x 13 1/2 in. (44 x 34.5 cm.)
From *Lilliput*, June 1957

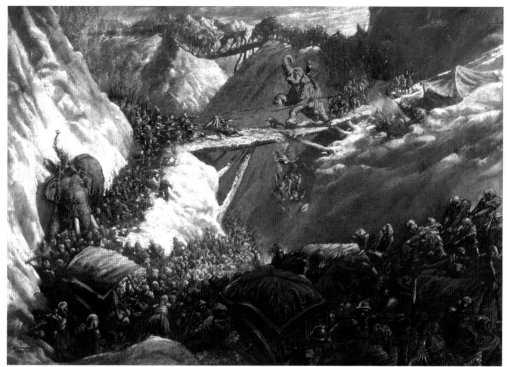

Cat. 87 - *Crossing the Alps*, pastel on coloured paper, 21 5/8 x 31 in. (55 x 78.5 cm.)

A newspaper cutting reviewing the 1951 Mildon Arts Society annual exhibition (of which Sheppard was the Chair and Edward Halliday the President) states that Dame Laura (Knight) singled out *Crossing the Alps* for particular praise: " '*This painting alone makes my visit more than worthwhile,' she told the committee*". (*Mill Hill News*, 1951, issue number unknown)

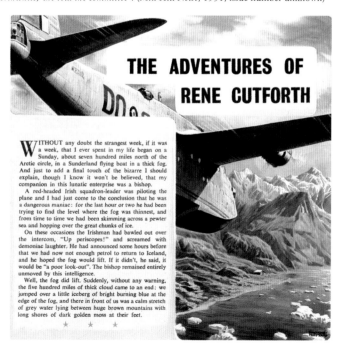

Cat. 88 - *The Adventures of René Cutforth*, pencil and gouache on card, 10 5/8 x 11 in. (27 x 28 cm.) Original drawing for January 1956 issue of *Lilliput*

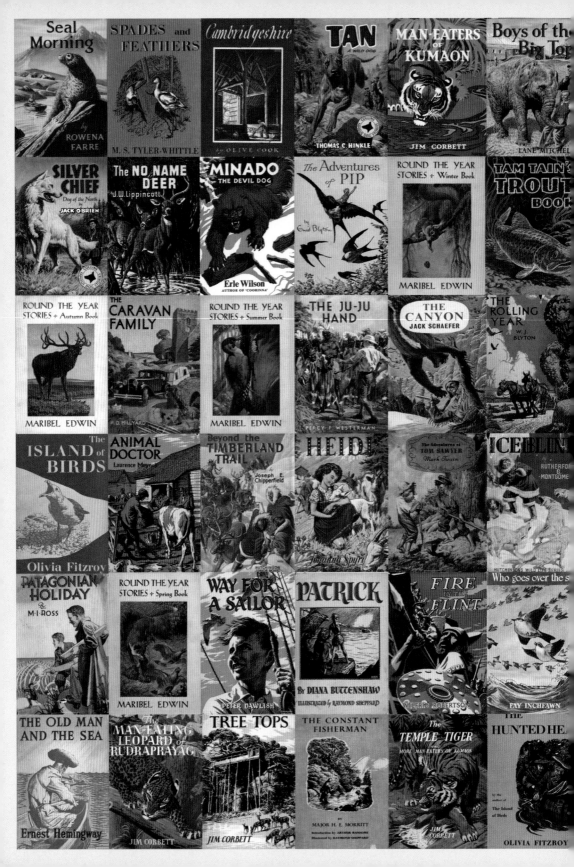

BOOKS ILLUSTRATED BY RAYMOND SHEPPARD

(publisher and year of publication indicated when possible)

1930s

English Cavalcade / W. J. Blyton		1937
Patagonian Holiday / M. I. Ross	George Routledge & Sons Ltd	1934
Salar The Salmon / Henry Williamson	Faber & Faber Ltd	1935
Spangler's Circus / Katharine L. Oldmendor	Blackie & Son Ltd	1935
The Rolling Year / W. J. Blyton	Blackie & Son Ltd	1936
The Story of Heather / May Wynne	Thomas Nelson & Sons Ltd	1936
Round the Year Stories / Maribel Edwin	Thomas Nelson & Sons	
The Spring Book		1938
The Summer Book		1938
The Autumn Book		1939
The Winter Book		1939
The Silent Hunter / Phyllis Briggs	Blackie & Son Ltd	1939
Patrick / Diana M. Buttenshaw	Macmillan & Co	1939
Macmillan & Co		
The Ju-Ju Hand / Percy F. Westerman	Blackie & Son Ltd	1939

1940s

(NB: *Tales & Talks Series* includes *Stories of Farm & Home* and *A Book About Animals*)

The Caravan Family / M. D. Hillyard	Blackie & Son Ltd	c. 1940
Stories of Farm & Home	Blackie & Son Ltd	
A Book About Animals	Blackie & Son Ltd	
How to Draw Birds / Raymond Sheppard	Studio Publications	1940
Macmillan's Easy Study Series:		
My Book of Wild Flowers / W. M. Daunt & E. J. S. Lay		1944
My Book of Insects, Seashore, Animals & Fish / Kate Harvey & E. J. S. Lay		1946
My Book of Birds		
My Book of Animals and Trees		
Tam Tain's Trout Book	W & R Chambers Ltd	1947
Hampton on Pike Fishing	W & R Chambers Ltd	1947
Drawing at the Zoo / Raymond Sheppard	Studio Publications Ltd	1949
Britain's Beasts of Prey / W.Kay Robinson	Latimer House Ltd	1949
Boys of the Big Top / Lane Mitchell	Blackie & Son Ltd	1940s
The Nature Lover's Companion / Various	Oldhams Press	1949

Children's Wonder Book in Colour 1948

Jolly Pets / Elizabeth Gould

1950s

The Children's Golden Treasure Book / Various Oldhams Press

The Children's Book of Games

The Pony Club Annual / The Naldrett Press for the British Horse Society 1952

Puzzles & Pastimes Oldham's Press Ltd

"Life on the Seashore"

"Birds"

"Birds & Bird Watching"

Children's Annual Blackie & Son Ltd

The Young Traders / John Hornby Blackie & Son Ltd 1951

*The Adventures of Huckleberry Finn / Mark Twain (The Stanhope Library) Blackie & Son 1951

*The Fifth Form at St Dominic's / Talbot Baines Reed Blackie & Son Ltd 1951

*Beyond the Timberland Trail / Joseph E. Chipperfild Hutchinson & Co Ltd 1951

The Crusader Series (soft cover booklets) : Blackie & Son Ltd
Algerian Adventure / Dorothy King 1952
Avocet Island / John Hornby 1951
Dangerous Journey / John Kennett 1955
River of Silver / Joseph Grau 1951
Sahara Adventure / George Bell 1955
The Deserted City / Fay King 1951
The Ivory Peaches / Geoffrey Field 1955
The Men O' The Mists / John Hornby 1951
The Mystery of Middle Tree Island / I.M. Knight 1952
The Riddle of Monk's Island / T.F. Maher 1952
The Stowaway / George Bell 1955
Tiger Hunt / P.A. Baron 1952

Who Goes Over the Sea? / Fay Inchfawn Lutterworth Press 1953

The Old Man and the Sea / Ernest Hemingway Jonathan Cape & Reprint Society 1953

The Island of Birds / Olivia Fitzroy Jonathan Cape 1954

Black Beauty / Anna Sewell Blackie & Son Ltd 1954

Redskins and Cowboys / G. A. Henty Blackie & Son Ltd 1954

The Canyon / Jack Schaefer Andre Deutsch Ltd 1955

Spades and Feathers / M. S. Tyler-Whittle Jonathan Cape 1955

Heidi / Johanna Spyni The Stanhope Library, Blackie & Son 1955

Way for a Sailor / Peter Dawlish Oxford University Press 1955

Unlawful Cargo / S. F. Stevens	Oxford University Press	1955
Animal Doctor / Laurence Meynell	Geoffrey Cumberlege, Oxford University Press	1956
More Birds to Draw / Raymond Sheppard	Studio Publications	1956
The Hunted Head / Olivia Fitzroy	Jonathan Cape	1956
Man-Eaters of Kumaon / Jim Corbett	Oxford University Press	1952
Jungle Lore / Jim Corbett	Oxford University Press	1953
Man Against Man-Eaters / Jim Corbett	Oxford University Press	1954
The Man-Eating Leopard of Rudraprayag / Jim Corbett	Oxford University Press	1954
Tree Tops / Jim Corbett	Oxford University Press	1955
The Temple Tiger / Jim Corbett	Oxford University Press	1957
The Adventures of Tom Sawyer / Mark Twain	Blackie & Son Ltd (Stanhope Library)	1957
Fire in the Flint - a Tale in Seven Scenes / Wilfred Robertson	Basil Blackwell, Oxford	1957
Seal Morning / Rowena Farre	Hutchinson & Co Ltd	1957
The Constant Fisherman / Major H. E. Morritt	Adam & Charles Black	1957
Trylla & Other Small Fry / Gunnar Gunnarsson	Hutchinson	
The Adventures of Pip / Enid Blyton	Sampson Low, Marston & Co Ltd	
More Adventures of Pip / Enid Blyton	Sampson Low, Marston & Co Ltd	
Birds of the Garden / Elizabeth Gould	Blackie & Son Ltd	
Birds of Moorland Hill & Sea / Elizabeth Gould	Blackie & Son Ltd	
Birds of Meadow & Sea / Elizabeth Gould	Blackie & Son Ltd	
Birds of Woodland & Hedgerow / Elizabeth Gould	Blackie & Son Ltd	
Heidi (different publication) / Johanna Spyni	Blackie & Son Ltd	
Iceblink / Rutherford G Montgomery	Hutchinsons Books for Young People	
The Adventures of Huckleberry Finn / Mark Twain	Blackie & Son Ltd	
The Adventures of Tom Sawyer / Mark Twain	Blackie & Son Ltd	
The Drama Merry-Go-Round / Eric Newton	Blackie & Son	
Tan – A Wild Dog / Thomas C. Hinkle	Collins	
Silver Chief- Dog of the North / Jack O'Brien	Collins	
Minado- the Devil Dog / Erle Wilson	Andre Deutsch	
The No Name Deer / J. W. Lippincott	Macmillan	
Wild Animals in Britain (Part 1)		
Wild Animals in Britain (Part 11)		
Wild Animals in Britain (Part 111)		

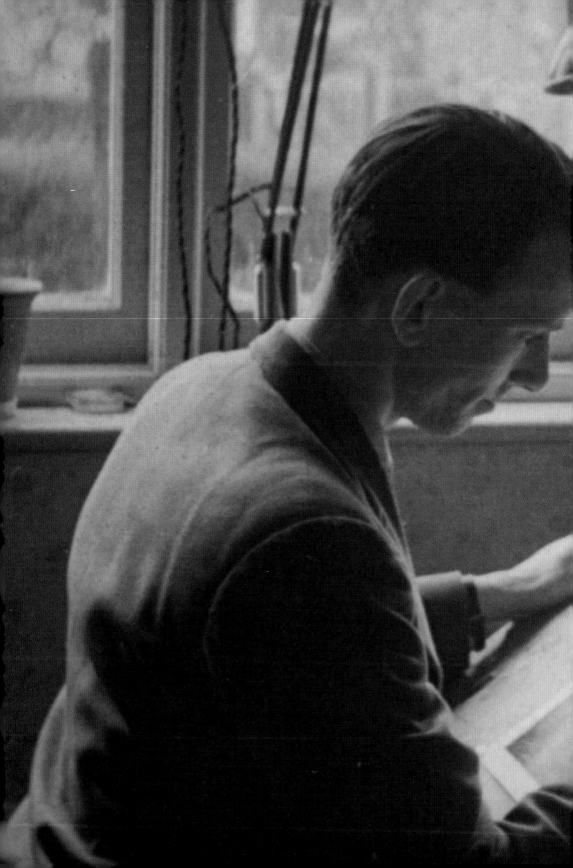

Chronology

CHRONOLOGY

1913 March 3rd, born in Muswell Hill, north west London. Educated at Christ's College, Finchley, London. His father, Edward, was Irish and his mother, Annie (nee Yates), English; of mixed middle and working class backgrounds, both raised in Lancashire. Edward worked as a manager for Pilkington's Pottery, sourcing designs; Annie, who had attended art school, was an accomplished painter (mostly of still lives and flowers) and a skilled needle-woman.

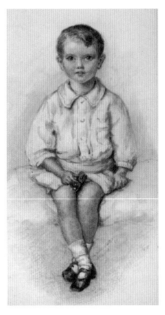

Fig. 9 - Raymond Sheppard at the age of three, painted by his mother Annie

1928 Enrolled in the Elementary Course of John Hassall's Correspondence Art School – complimented on his "remarkable understanding of the correctness of drawing."

1931 Studies at the London County Council School of Photoengraving and Lithography, (Bolt Court Fleet Street), under S.G.Boxsius - a non fee paying technical school where students were able to take classes in design, drawing, lettering, engraving and photo-mechanical processes. Sheppard later returned to teach there, for a brief period, in 1946.

1934 At age of 21 embarks on career as a freelance artist. Inspite of taking commissions for advertising and illustration Sheppard struggles financially. Rents a room in Hampstead, in same house as artist Gregory Brown.

Studies at the London Zoo, Regents Park – the only way for an artist with limited means to see live animals, birds and insects from around the world.

1939 Starts painting along the Thames with members of the Longham Sketching Club leading to the founding of the Wapping Group in 1946.

1940 October, joins RAF; selected for aircrew training – declared medically unfit and serves instead as Leading Aircraftman; stationed at RAF Benson. Subsequently placed for training in the School of Photography at Farnborough, based near Marlow. Befriends photographer Andrew Carr.

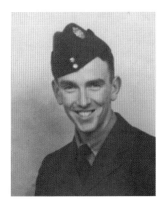

Fig. 10 - Raymond Sheppard in the RAF, c. 1940

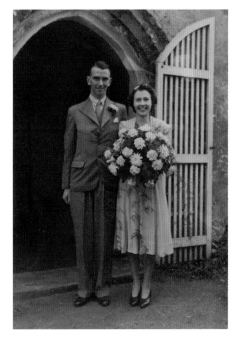

Fig. 11 - Raymond Sheppard and Iris Gale on their wedding day.

1941 December 3rd, marries Iris Gale during short leave from RAF duties; honeymoon in The Rising Sun pub in Lynmouth, Devon.

The couple rent rooms in 361 Hendon Way, NW4 for a short while.

1944 March 17th, daughter Christine born.

1945 Sent to Coulommiers, France, as part of the RAF Photo-
graphic Reconnaissance Wing. Visits the Jonte, Ardeche
and Dordogne regions, whilst off duty, on sketching trips.

1946 January, leaves RAF to resume career as an artist.
Moves to 65 Dorchester Way, Kenton Middlesex; a small
three bedroom semi-detached house where the front
room served as his studio.
Exhibits *After Rain: St. Olaves"* (866) at Royal Academy.
July 25th, son Michael born.
Elected Fellow of Zoological Society.

1947 Elected member of Society of Graphic Artists.

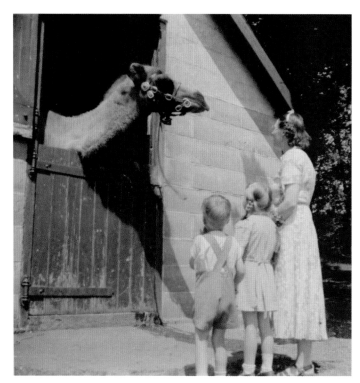

Fig. 12 - Iris and the children at the zoo

1948 Elected member of Pastel Society.

1950 Exhibits *Litter of Saddlebacks* (658) and *Christine and Michael* (722) at Royal Academy.

1951 November 14th, one-man exhibition at Foyles Art Gallery, London.

1952 Exhibits *Turtles* (914) at Royal Academy.

1954 Moves to a larger chalet bungalow house in Harrow Weald, with a large garden and a separate room as a studio.

1955 Exhibits *Servals* (797) at Royal Academy.

1958 April 21st, dies after a long battle with cancer.

2008 *Raymond Sheppard, Capturing the Moment* – exhibition organized by Nature in Art Trust, Gloucester, 14th October to 9th November.

2009 *Raymond Sheppard, Capturing the Moment*, published by Langford Press; Raymond Sheppard exhibition held at The Wildlife Art Gallery, Lavenham, Suffolk.

LISS FINE ART LIMITED

paul@lissfineart.com sacha@lissfineart.com www.lissfineart.com

Telephone: 0207 380 1131

Founded in 1990, Liss Fine Art specialises in the unsung heroes and heroines of British art 1880 - 1980. The company produces annual catalogues and has curated a series of exhibitions in association with national museums and the Fine Art Society Plc, London.

Areas of particular interest include:

Artists of the British School at Rome
Women artists pre-1950
Painters in tempera pre-1950
Mural painters pre-1950
Artists' studios pre-1950
Woodblocks (as objects) pre-1950
Artists of the interwar years, especially Slade and Royal College of Art students
Sculptures, especially original works in plaster
Paintings of the First and Second World Wars
Frank Brangwyn and his students

Liss Fine Art sells to museums throughout the UK and in the rest of Europe, the United States (including the Metropolitain Museum, New York, The Yale Center for British Art, New Haven), Canada, Australia and New Zealand. UK clients include the Tate Britain, the Victoria and Albert Museum, the House of Commons (permanent collection), the Imperial War Museum, the Science Museum, the British Museum, the National Portrait Gallery and the Geffrye Museum (all in London), the Fitzwilliam Museum, Cambridge, the Ashmolean Museum, Oxford; Leeds City Art Gallery; Southampton Art Gallery; Wolverhampton Art Gallery; Cheltenham Art Gallery; the Ferens City Art Gallery, Hull; and the Scottish National Gallery of Modern Art, Edinburgh.

The company also builds collections for both private and corporate clients. In 2000 Liss Fine Art was awarded the Corporate Art Award for the Laporte Art Collection.
Liss Fine Art offers for sale, exclusively through its website, a selection of new works every month. The majority of these works are sourced privately or have come directly from artists' estates.

Liss Fine Art has organised the following exhibitions: Winifred Knights (1995); Thomas Monnington (1997); Charles Mahoney (1999); Robert Austin (2001); Frank Brangwyn (2006); Michael Canney (2006); Cecil Stephenson (2007) - all in association with the Fine Art Society Plc - and Stanley Lewis and His Contemporaries (2010), in association with The Cecil Higgens Gallery & Bedford Museum.

Designed by David Maes
Text © Paul Liss and Sacha Llewellyn
Photography by Glynn Clarkson
Printed by SYL, Barcelona 2010
ISBN: 978-0-9567139-0-2

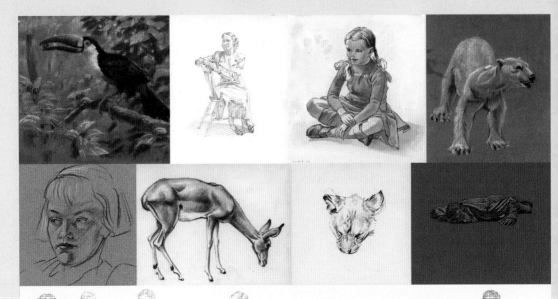

more works by Raymond Sheppard can be viewed at

www.lissfineart.com

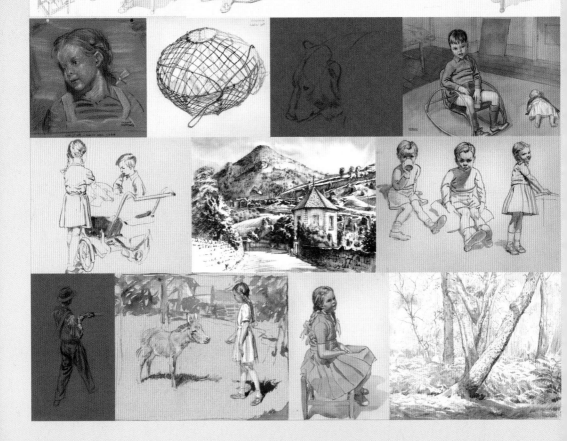